Perspective Without Pain

Volume 2/Part 1
Curves and Inclines

Benedikt Taschen

To Shirley Porter

Acknowledgments

When North Light asked me to consider writing a set of workbooks on perspective, my greedy eyes lit up and I said, "SURE!" I figured perspective was a snap and I could knock it off in a few weeks. Now, months older and somewhat chastened, I realize that there's more to the subject than meets the eye. There are thick books about perspective that dig deep into the mathematics and mystery of the subject. My job was to come up with skinny books that dispelled the mystery and concentrated on those aspects of perspective that someone in the "fine arts" would need to know. If you're an architect or an engineer, these workbooks are not for you. But if you draw and paint as a hobby or for a living, I think you'll find them just about right.

I want to thank two people who participated in producing these workbooks: Linda Sanders, my excellent editor at North Light, who kept steering me in the direction a workbook must take and really worked with me rather than sit back and accept whatever I threw her way; and Shirley Porter, who supplied a couple of the sketches in the workbooks, but who mainly read my prose before I submitted it to Linda and savagely deleted most (but not all) of the dumber things I had written. I honestly thank you both.

Perspective: the science of painting and drawing so that objects represented have apparent depth and distance ...

The Merriam-Webster Dictionary

Introduction

So far, in Volume 1, we've dealt mostly with neat blocks, straight lines, and two vanishing points. Happily, there's a lot more variety than that among the things we draw and paint. There are all kinds of curves and inclines, for example, and there are, as astronomer Carl Sagan might say, billions and billions of vanishing points. Such rich variety offers endless possibilities for our art, but does it also bring on endless headaches? How do we approach drawing all those odd shapes in perspective? And how do we deal with multiple vanishing points?

The way to deal with an apparently new problem is to start with the things we already know. We know how to draw rectangular objects in perspective, so it makes sense to try to see a new, odd-shaped object as being roughly rectangular or as being made up of a number of rectangles or parts of rectangles. If an object is curved, we can usually envision it as being placed within a rectangular box, so we draw that box in perspective and "fit" the curved object inside it. As for all those

vanishing points, we normally have only two, or at most three, to be concered with at any one time. Very often we only need to know the general locations of vanishing points and never have to pin them down precisely. As this workbook will demonstrate, you can solve most perspective problems with the tools you already have.

Materials You'll Need

All you really need are some pencils (2B-soft, HB-medium, and 2H-hard will suffice), or charcoal if you prefer; some tracing paper; a straightedge; two push pins; a piece of string about fifteen centimeters long; some cardboard; a hand-held-mirror; a piece of rigid plastic, such as Plexiglas; and a few other odds and ends you probably have around the house.

Getting Started

To begin learning how to handle the problems presented by curves in perspective, we'll first address the circle. Drawing circles may seem easy, but when they're seen in perspective, they are transformed into a less well-known relative of the circle, an *ellipse*.

Just what is an ellipse? Although there is a precise mathematical definition of an ellipse, it's easier just to think of it as a squashed-down circle. J.D. Salinger describes a character in one of his stories as having a head that appeared to have been squeezed in a carpenter's vise. That head would be an ellipse.

Ellipses can be fat (almost circular) or thin (almost a straight line) or anywhere in between. There are plenty of objects around that are actually made in an elliptical shape–platters, serving bowls, swimming pools, and so on. Most ellipses we see, however, are really *circles seen in perspective*, and it's those ellipses we're most concerned with here.

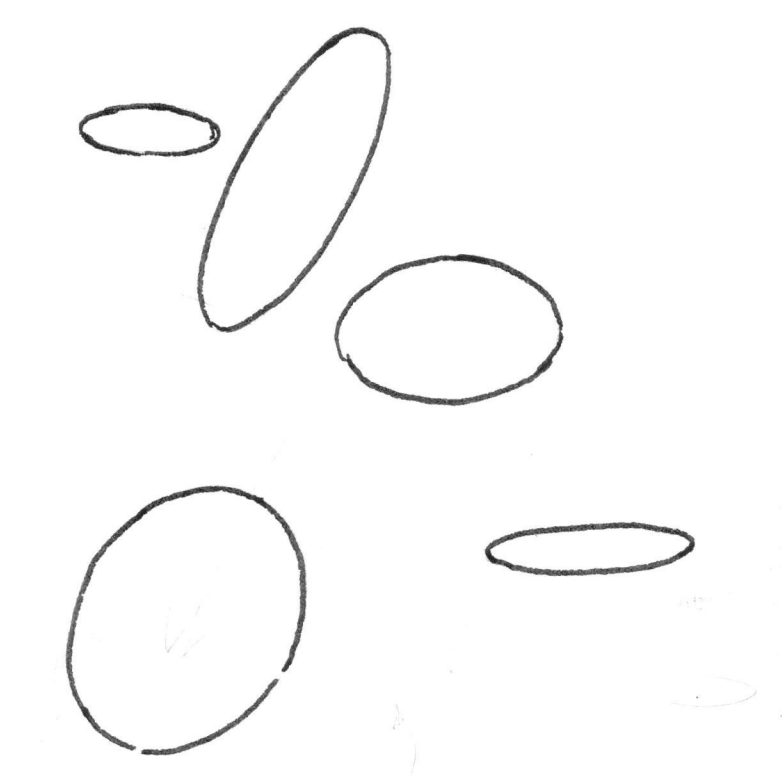

Circles and Ellipses

Take a can of beans from the pantry and look at its top. If you view it straight on, it's circular.

But if you view it from the side, the top may look like one of the other two drawings **below**.

Think of an ellipse this way: it's a circle tilted away from you.

As you snoop around the pantry you'll find elliptical shapes galore. Glance out the window at your car. If it's parked at an angle to you, its wheels and tires all appear elliptical. Look at the top of a lampshade, a phonograph record lying at a distance, a saucer – they're all really circular, but they appear elliptical when viewed from most positions.

Let me repeat: an ellipse is a circle in perspective. If we can figure out how to draw a circle in perspective, we'll end up with an ellipse. To find out how to draw a circle in perspective, we'll go back to a more familiar object, the square. As you probably know, a square is a rectangle with all four sides equal. A circle can always be drawn inside a square, and it will touch the square at the middle of each of its sides. The center of the circle will be at the same point as the center of the square – that is, the place where the square's diagonals cross. **Bottom left** is a circle drawn inside a square (or, if you prefer, a square drawn around a circle).

Suppose we turn this square slightly away from us **(bottom right)**. The square is now in perspective, its top and bottom edges retreating to some distant vanishing point. But the circle has also taken on a different shape: it's become an ellipse. Draw the diagonals in the figure to locate the square's perspective center, as shown in Volume 1, Part 2. That point is also the perspective center of the ellipse.

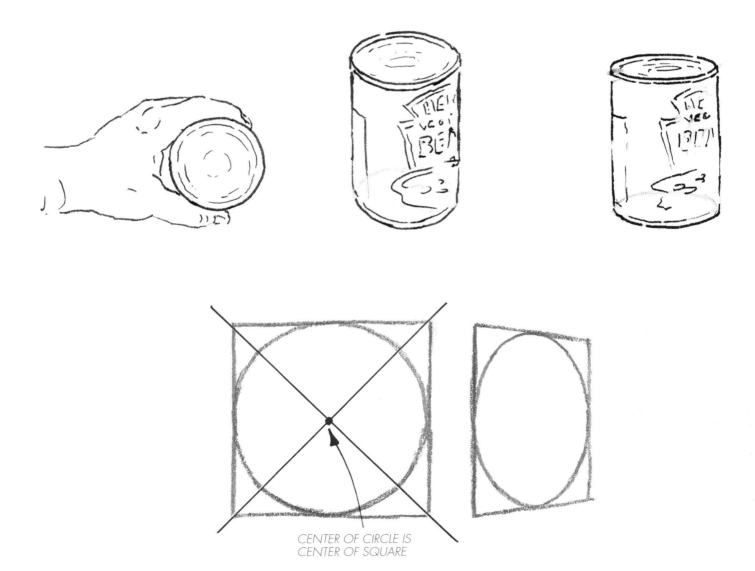

CENTER OF CIRCLE IS
CENTER OF SQUARE

Drawing Ellipses

You can draw ellipses in a variety of ways. Done freehand, they may at first tend to look like the ones at **top right**.

There are two problems here. The first is that an ellipse never has sharp points any more than a circle does. Keep in mind that at its narrowed "ends" an ellipse is still a curve; it never stops abruptly to change direction, but simply keeps curving around until it has *gradually* changed direction. The horses at an oval racetrack don't stop and change directions; they just keep on leaning and traversing the curved track.

The second thing to remember is that an ellipse is a uniform curve; it's not teardrop-shaped, fatter at one end than at the other.

Most of the time you'll sketch an ellipse without actually sticking it inside a perspective square. But if you're doing some ticklish drawing where you want more accuracy – maybe you're illustrating a piece of machinery, for instance – it may be a good idea to start with the square, with its perspective center located **(right center)**.

Then mark the perspective center of each side of the square **(far right center)**.

Now lightly sketch in a curve that touches the perspective square at each of the four points you've marked, and nowhere else. (In mathematics, one would say those four points are where the curve is tangent to the square.) Notice that the curve sweeps smoothly through the four points where it touches the perspective square, rather than change direction abruptly at those points **(bottom right)**. It's important to remember those smooth curves so that you avoid drawing curves like the one at **far right bottom**.

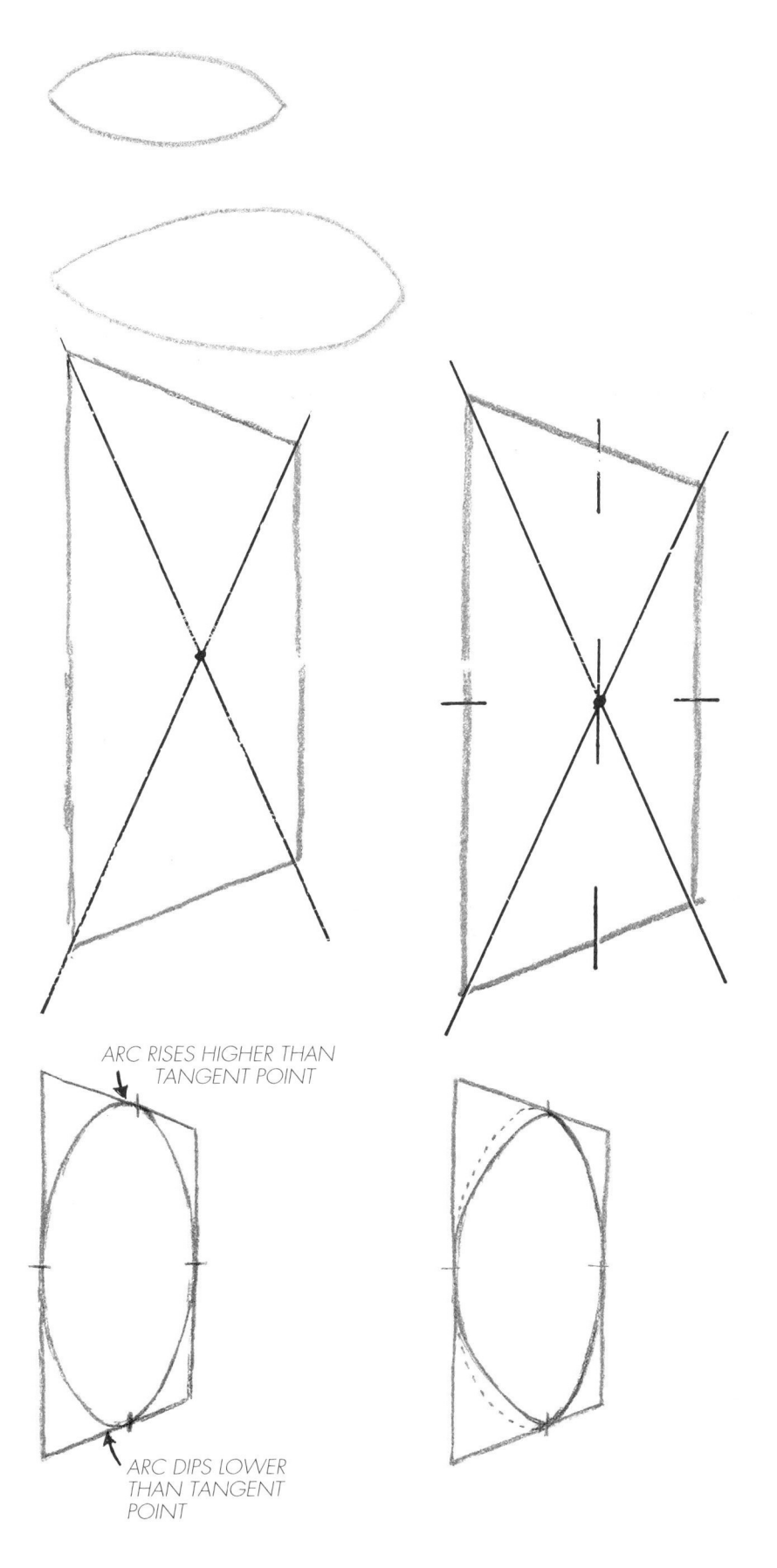

ARC RISES HIGHER THAN TANGENT POINT

ARC DIPS LOWER THAN TANGENT POINT

Exercise 1/**Getting the Feel of Ellipses**

In this exercise we'll construct some ellipses that actually conform to the mathematical definition of an ellipse; however, we will not get into any of the mathematics. All I want is for you to understand the shape of a true ellipse. I'm not proposing you actually construct ellipses in this manner in your drawings – never!

You'll need two push pins, a pencil, a piece of string, and a piece of cardboard.

Step 1: Stick two push pins into a piece of cardboard; place them about ten centimeters apart. Fasten the ends of a piece of string about fifteen centimeters long to the two push pins. (The easiest way to fasten the string is to stick the pins right through it.) Make the string taut by inserting the tip of a pencil into the loose loop.

Step 2: Keeping the string taut with the pencil, draw a closed curve. Don't worry about doing this all in one smooth movement – the string will get wound around the pencil point and you'll have to untangle things once or twice. If you succeed without pulling the push pins loose, you'll end up with a true ellipse.

Now try the same exercise, varying both the distance between the push pins and the length of the string. Just for your information and intellectual enlightenment, the names of the two points where the pins are located are the foci; the long dimension the foci fall on is the major axis; the line perpendicular to the major axis and bisecting it is the minor axis. Now don't you feel smart?

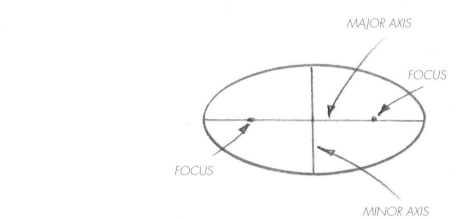

MAJOR AXIS

FOCUS

FOCUS

MINOR AXIS

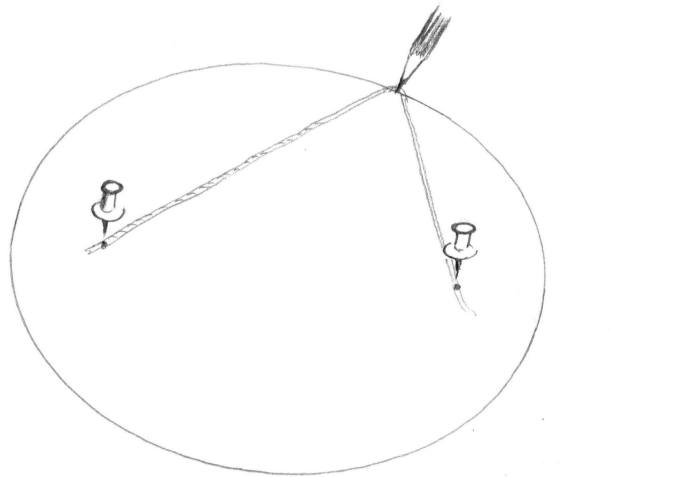

Here are two squares in perspective. In both I have indicated the points at which an inscribed ellipse should touch the sides. In the first I've already drawn an ellipse freehand, which looks reasonable. Notice that it only touches the square at the left and right tangent point. Notice, too, that after rouching the square at the left and right tangent points, the curve curves even wider before gradually changing its direction. The widest dimension of the ellipse is not at the tangent points.

Trace over the curve to get the feel of how it travels. Then draw a similar curve in the remaining perspective square **(bottom right)**.

Hint on drawing curves: for most people, it's easiest to draw a curve that curves away from one's body. To do so, draw part of the curve and then rotate the paper to draw the next portion. A couple of rotations later the curve will be closed.

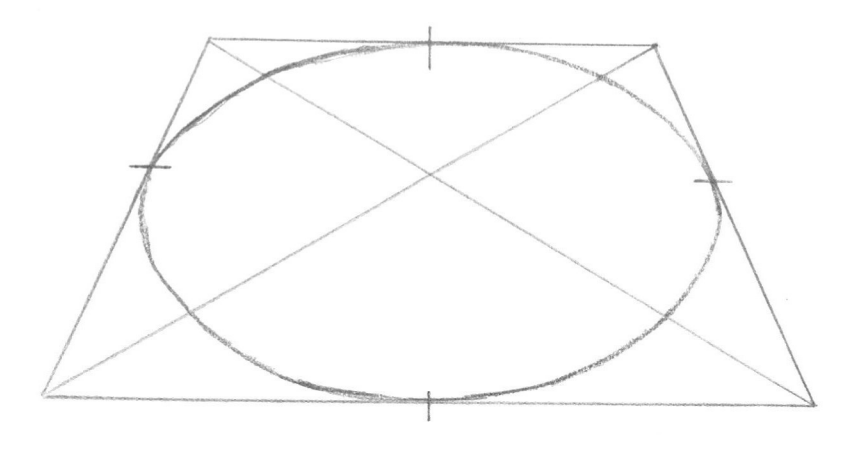

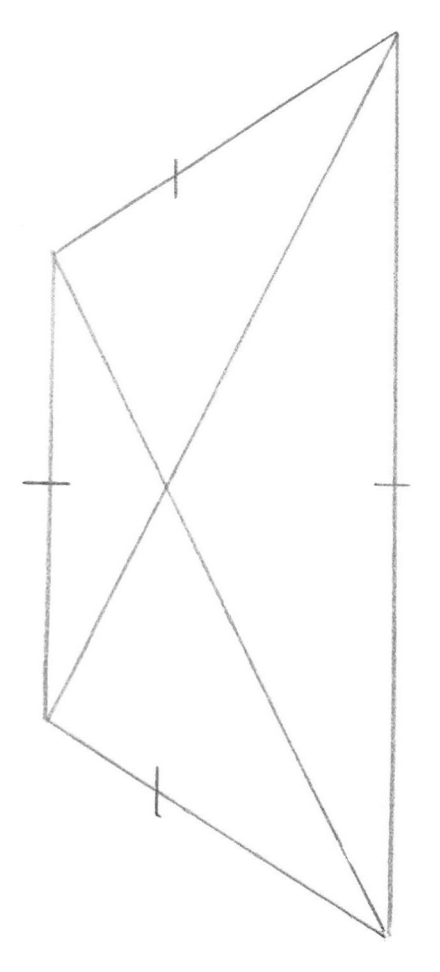

Here are some squares in perspective. Practice making ellipses (circles in perspective) by inscribing an ellipse in each "square." Some of the squares already have their diagonals drawn, some have tangent points shown. Remember, the curve of the ellipse touches the sides of the square only at those tangent points. Be sure your curves sweep gracefully through the tangent points rather than abruptly change direction at those points.

TANGENT POINT

TANGENT POINT

TANGENT POINT

TANGENT POINT

We're not often concerned with drawing simple, flat circles in perspective. What we're generally concerned with is drawing three-dimensional objects whose cross sections are circular – objects such as bottles, columns, silos, and trees. Let's see how what we've learned about ellipses applies to these objects.

The Importance of Eye Level

Before we begin, let me repeat one important piece of advice. In Volume 1, I stressed the importance of establishing the eye level in a picture before doing any drawing. This admonition applies not only to rectangular objects, but to circular and other curved objects as well. Failure to nail down the eye level is one of the most common errors in painting and drawing.

In countless still lifes I've seen weird vases like the one **above center**. The top of the vase suggests that the eye level in the picture is somewhere above it. But the flattened bottom insists that the eye level is even with the bottom of the vase. It may be that the still life painter was imitating a famous artist who used distortion to

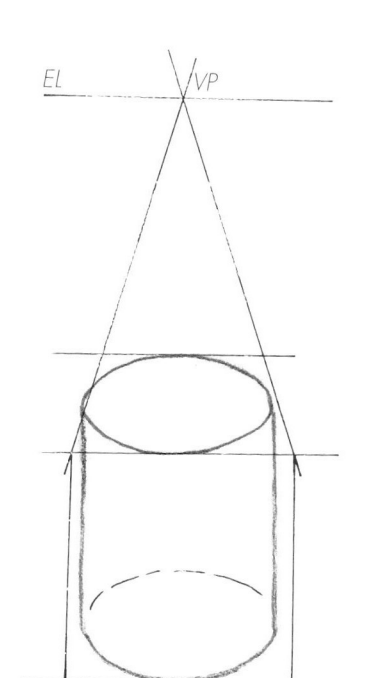

make a point. By all means, distort things if you will, but be sure you're doing it on purpose.

Now let's go back to the pantry and get out that can of beans. Instead of viewing only its ends as circles inside squares, let's see the entire can as a cylinder encased in a rectangular box **(above right).**

I've included only enough construction lines to suggest the box; as an exercise you may want to fill in the hidden edges of the box. It's important to notice that the bottom of the can, the end farthest from your eye level,

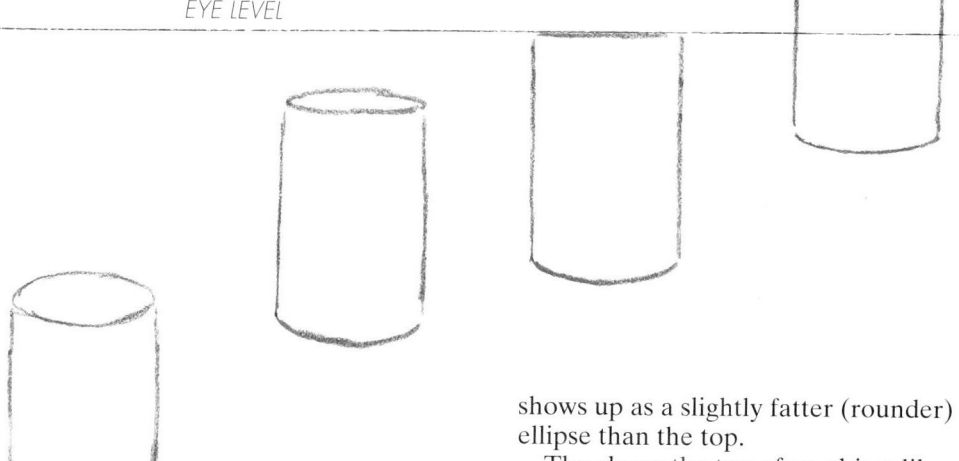

shows up as a slightly fatter (rounder) ellipse than the top.

The closer the top of an object like a can gets to your eye level, the narrower the ellipse, as shown here. When the top of the can is precisely *at* your eye level, there is no more curve

visible – what you see is a straight line. And if you raise the can above your eye level, the top ellipse is now the fatter one. An ellipse near eye level is narrower than one farther from eye level because you're seeing it in more severe perspective.

Circular Objects

Now forget about beans. Let's talk money! **Below** is a picture of my first royalty payment for writing this book. Let's remove what the IRS will claim. That leaves us with about seventy-five cents **(right)**.

Notice that each coin is an ellipse drawn in a square in perspective. The farther away from your eye level, the fatter the ellipse.

Let's look next at a landscape example. In the sketch **below**, the barn

and one of the silos seem to have withstood weather and age. The other silo was done by a guy from Pisa.

The problem with the leaning silo is one of exaggerated perspective. The bands encircling the silo have been given too much curvature. This is usually caused by starting the drawing of the bands at the wrong place. If you start near the bottom, where the eye level is in this case, you'll naturally enough give each succeeding band

more curvature as you go up the silo – the ellipses get fatter as they get farther from eye level. By the time you get to the top band, you give it more curvature than all the rest; you've overdone it and your silo falls over backwards.

A way to avoid this is to start at the end with the *maximum* curvature – the top in this example – and then work your way toward the other end.

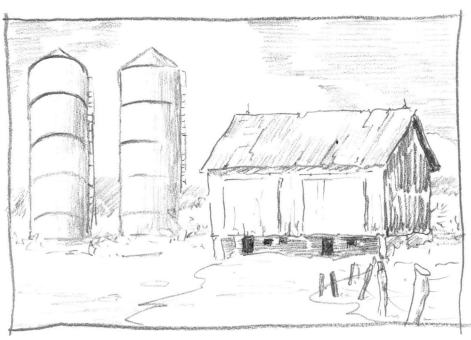

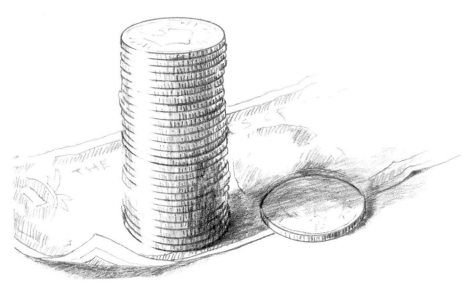

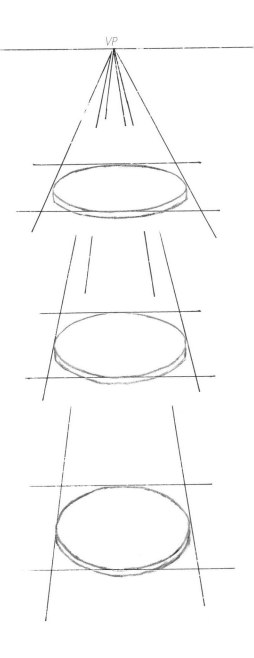

Here is a simple exercise to help you practice getting curves right. You'll notice the exercise does not ask you to draw perspective squares and inscribe curves within them. You could proceed in that manner, but that would take a lot of work – ugh! And even so, you'd still need to resort to trial and error just to get the perspective squares feeling right.

These parallel vertical lines are the sides of three silos. The silos have flat tops and bottoms. I've indicated the eye level in each case. Complete each silo by drawing in perspective its top, bottom, and five or so intermediate bands, keeping in mind how the eye level will affect the curvature of the bands.

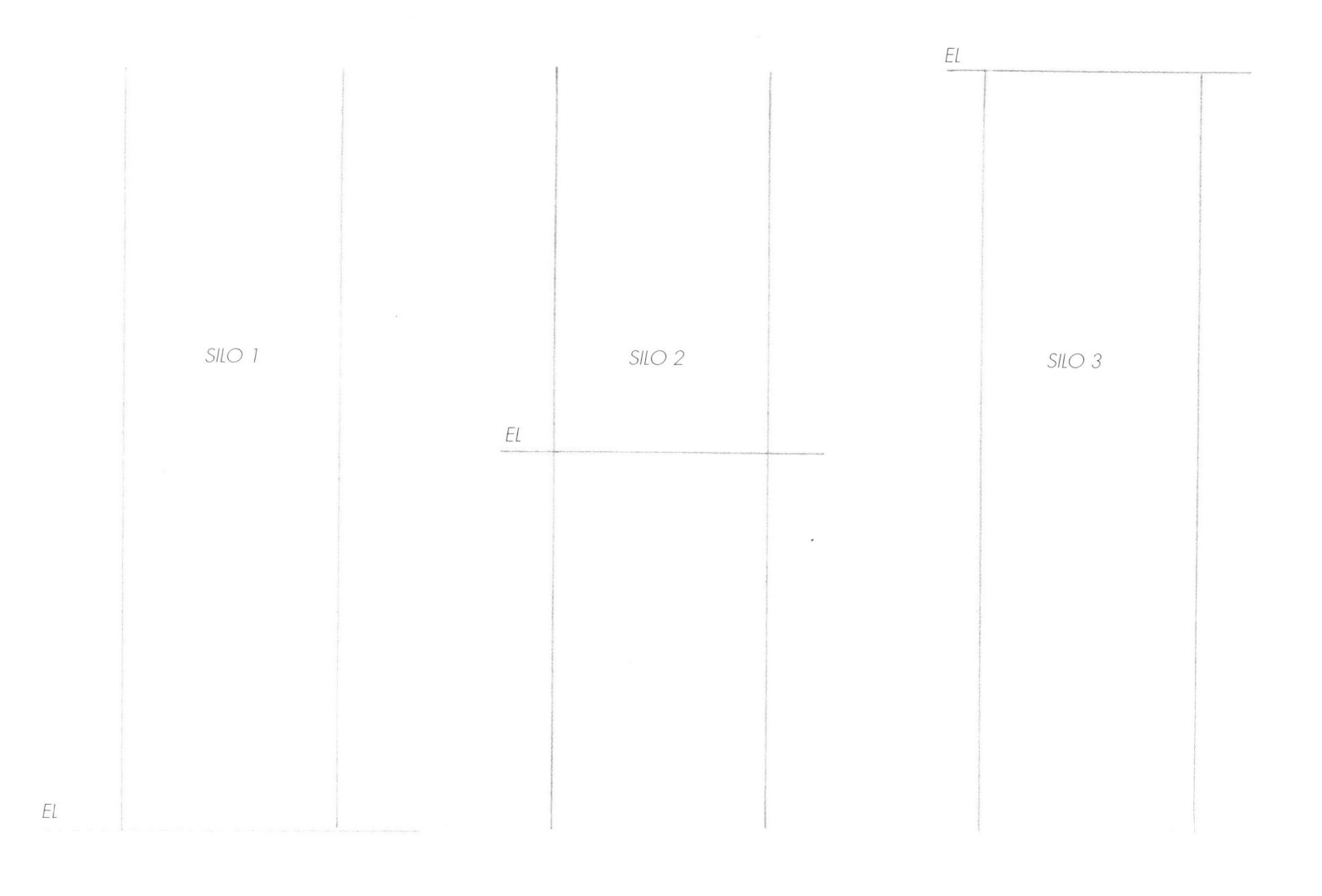

Combinations of Cylinders

Many of the objects you draw are not neat, single cylinders, like the silo or a can of beans or a stack of coins. Some are odd combinations of intersecting shapes. One of the most common objects we draw is a tree, and its skeleton may be thought of as a network of intersecting cylindrical shapes. Imagine this tree, **below**, to be composed of cylinders or a bunch of pipes installed by a crazed plumber **(bottom)**.

Sometimes it's easier to visualize pieces of pipe stuck together than to see what's happening to tree branches. I paint trees often, yet I still find this concept extremely helpful when I'm having trouble getting branches to advance or recede. You could play with the same idea by holding cans or other cylindrical objects at various angles to each other, although you'd be limited by how many objects you could manage. If there's a Tinkertoy set in the house, you can build a quite respectable three-dimensional tree from its parts.

People

You can apply the same idea to the human body to give it form and put its parts in perspective **(right)**.

People are full of curves! You might not at first think of human anatomy as an appropriate topic in a book on perspective, but please reconsider. One of the qualities we usually strive for in a drawing of a person is a sense of form, or solidity, as opposed to flat critters with no depth. And physical (as opposed to intellectual) depth is what perspective is all about. In a landscape we're concerned with kilometers of depth; in people we're concerned with meters or centimeters.

The human trunk and limbs are not so different structurally from the tree. In both cases, it's helpful to think of the parts as cylinders or approximate cylinders connected in a variety of ways. As with drawing trees, such analogies are helpful in trying to show human limbs advancing or receding.

(The term *foreshortening* is usually used in discussing drawings such as these. That simply means getting the appearance of depth by shortening certain lines, such as the lines of the arm or the lines of the branch. When we turn a building away from us so that one of its sides appears to be shorter than we know it to be, we're foreshortening that building.)

Thinking of the body as a combination of cylinders will help you to get it right. When you do a torso or an arm or a leg or a head, "draw through," as discussed in Volume 1, Part 2, to get a feel for their roundness. When you get down to smaller details, such as noses and eyes, "draw through" them and see them as solid objects, not simply outlines. It's common, for example, to see eyes expressed as flat almond-like shapes.

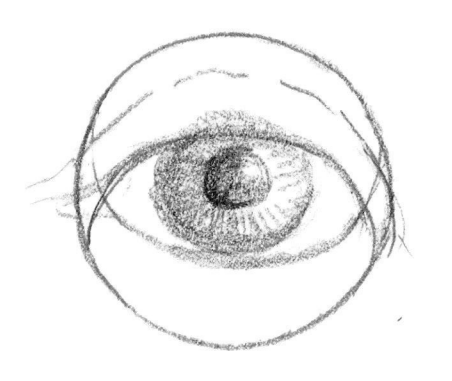

If you start with the understanding that an eyeball is nearly spherical and that lids wrap around this sphere, you'll come closer to drawing a believable eye.

Add some shadow cast by the upper lid and some shadowing (modeling) as the eyeball curves away from us, and your eye begins to live.

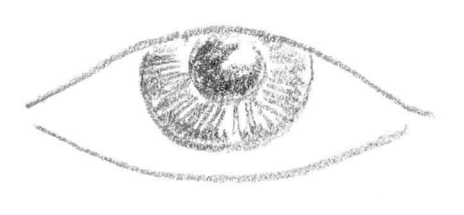

Combinations of Cylinders

Box Them In

As the examples of the tree and the human body illustrate, not all curved objects are upright cylinders. But whatever the subject, curved or not, it can be an enormous help to sketch in some construction lines and put objects in boxes, as shown here. This is helpful because an ordinary box is something we all are familiar with. It's an orderly, understandable thing. Anything we can force into a box, therefore, will also become more orderly and understandable.

Exercise 5 / **A Tree as a Combination of Cylinders**

An effective way to make a tree limb come forward or go back is to show the curve where the limb joins the trunk or another limb.

In the two sketches on **page 15** use a soft pencil to darken the appropriate portion of each circle or ellipse to make limbs go:

- Forward (F)
- Backwards (B)
- Sideways (S)

as in the example at **right**. Beginning with identical silhouettes, you'll see that you can end up with quite different trees.

When you're satisfied that the limbs go where they should, you might enjoy giving the tree more life by doing some modeling. Choose a light source (the sun) and then carefully darken each rounded surface facing away from the light. Gradually fade the shadows as each limb comes around toward the light. You might also add some smaller, twiggy branches, which I've left out in order not to confuse the picture.

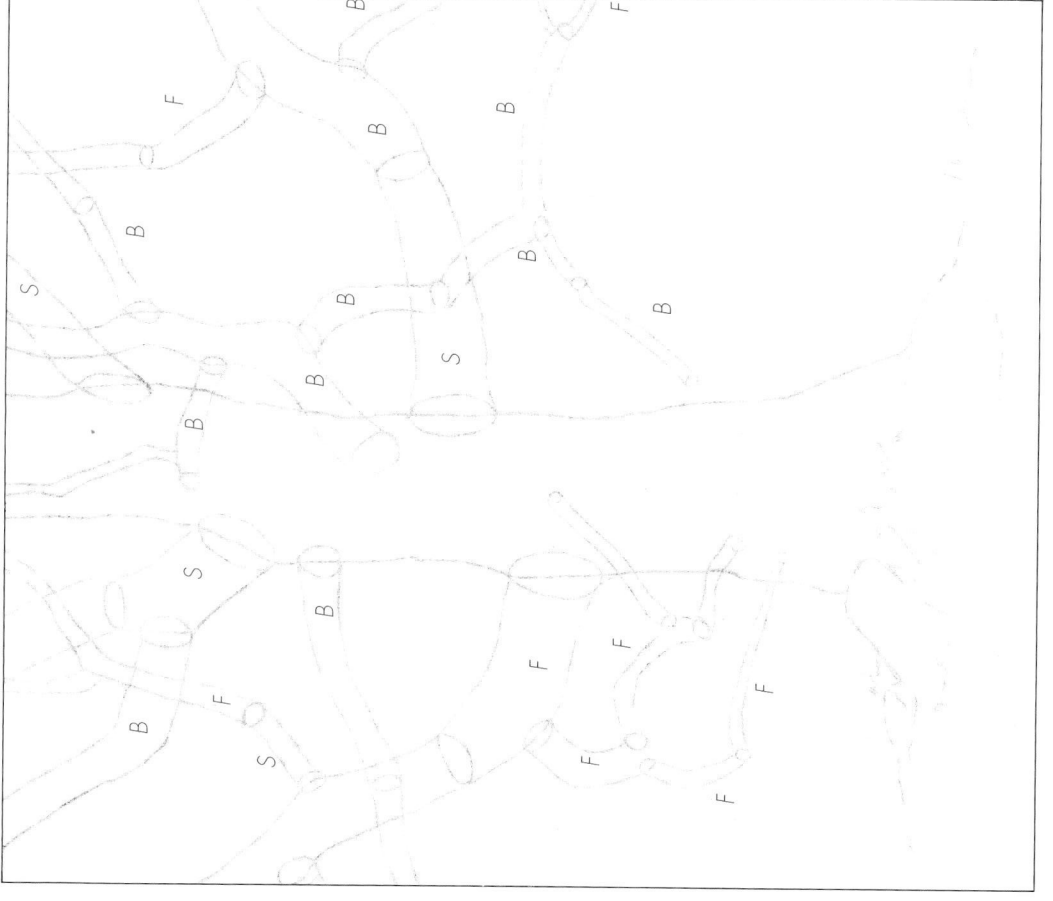

Arches

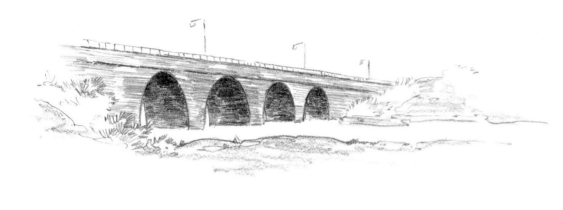

There are many curved objects around us whose drawing is more demanding than that of silos, cans, trees, and vases. One of the most familiar is the arch. Arches come in all sizes and shapes, some elliptical, some circular, some parabolic, and others rather free-form.

Arches such as those built into many bridges and public buildings provide attractive shapes for drawings and paintings. Some are complex and defy any easy approach to their drawing, but most can be constructed using some of the basic ideas we've already explored. Suppose we have a simple bridge, such as the one at **top left**.

We'll assume the top of the bridge is a level roadway without any curvature, although most bridges rise some toward their midpoints. Once you get a basic structure drawn you can easily add such details.

Where do you start? I would locate the eye level and then try the bridge freehand, as I would most subjects. But when I got in trouble (as I often do) I'd fall back on a little construction. First, I'd rough in a couple of light lines representing the upper edge of the bridge and the water line, and indicate the two ends of the bridge with a couple of vertical lines. The ends of the bridge might not be neat vertical lines, but you need some idea where the bridge begins and ends.

Next, find the perspective center of the side of the bridge by crossing diagonals.

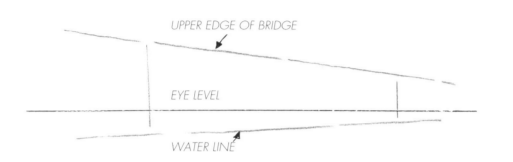

UPPER EDGE OF BRIDGE

EYE LEVEL

WATER LINE

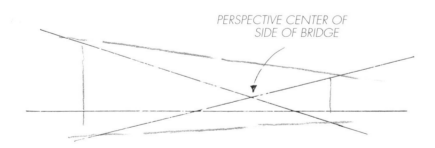

PERSPECTIVE CENTER OF
SIDE OF BRIDGE

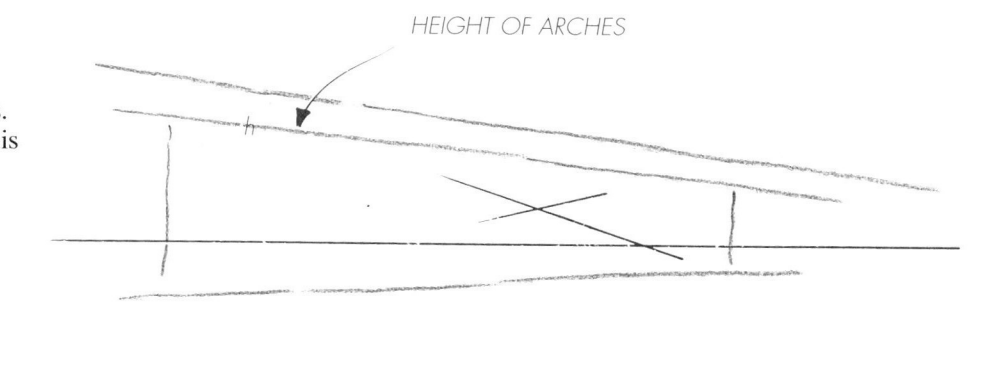

HEIGHT OF ARCHES

Now draw in a perspective line, *h*, representing the height of the arches. Each arch will curve up and touch this line.

Freehand, draw vertical lines representing the widths of the arches. This is the same as placing windows along the side of a building. If there is an odd number of arches, one arch will be in the middle of the bridge span, so start by locating an arch with its perspective center at about the same point as the perspective center of the entire side of the bridge. If there is an even number of arches, draw two vertical lines, one on either side of perspective center, representing the width of the solid bridge support between the arches.

Now work to either side of the start you made in the middle, guessing at increasingly larger arches and supports to the left and smaller to the right.

Arches

If you're satisfied with the space divisions, limber up your wrist and sketch in the arches. It might be helpful to locate the perspective center of each arch space first by drawing in the diagonals as I've done in **Figure 1** for the nearest arch. This will tell you at what point the arch is to touch the line you drew earlier showing the height of the arches. In small sketches, such as I'm using here, finding the perspective center for each arch is probably overkill. I show it only because in a larger, full-size painting, where all your dimensions might be much larger than here, such constructions can make a real difference.

Now the bridge needs width, or thickness. If you can see through the arches from where you're viewing the bridge, then draw the spaces you see. In **Figure 2**, in addition to showing those spaces I've added a few construction lines to remind you that this entire bridge can be thought of as a three-dimensional, rectangular solid with curved holes in it. Note that lines *a* and *b* slant toward a vanishing point at the left. Also notice that the water line under the arches aims for that same left vanishing point, while the water line on the face of the bridge heads toward the right vanishing point.

If this bridge were built of regular blocks of some kind, the mortar lines between the blocks would obey the rules of linear perspective. Those visible under the arches would slant toward the left vanishing point, as I've indicated, and those in the face of the

bridge would slant toward the right vanishing point, **Figure 3**.

All that's left is to embellish your bridge with detail and, of course, it would be nice if the bridge went from something to something.

This is a relatively simple bridge. There are many possible variations. When presented with any of the strange curves you may find in bridges, buildings, and other engineered objects, start with something basic that you're familiar with (such as the essentially rectangular side of the bridge in our example) and proceed from here. You can almost always mentally carve out sections that can be seen as rectangular solids, like that shown in **Figure 4**.

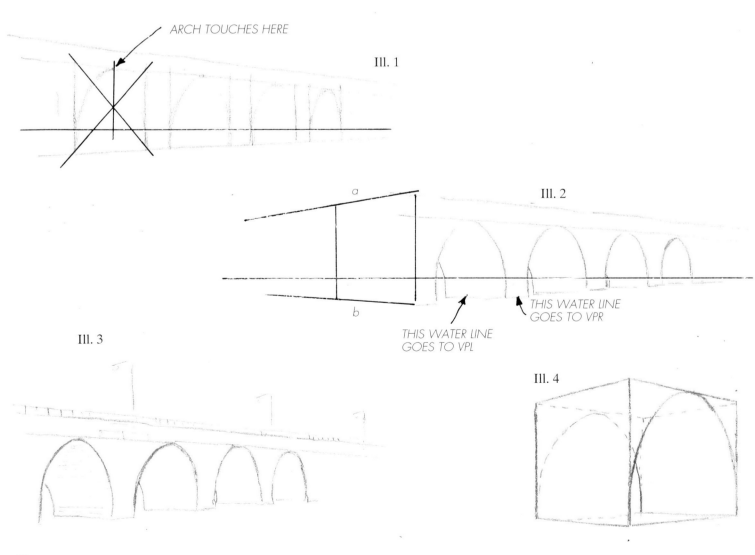

ARCH TOUCHES HERE

Ill. 1

a

Ill. 2

b

THIS WATER LINE GOES TO VPL

THIS WATER LINE GOES TO VPR

Ill. 3

Ill. 4

Exaggeration as an Aid to Seeing

Sometimes it's difficult to decide on the size or shape of something compared to something else because the objects are quite close in size and shape. You may decide that the difference between the two objects is too small to matter. But if it does matter and you still can't quite decide what's going on, you might try what I often do. I visualize the objects in some extreme or exaggerated setting and then see how they compare. For example, suppose I'm facing a stack of fat tires and trying to decide (a) whether the topmost tire appears rounder than a lower one, and (b) how much of the edge (the tread area) of the topmost one I'd see compared to the lower one **(below left).** I know the topmost tire would look rounder (more nearly circular) and I know I'd see less tread of the topmost one than the lower one. I had to pass that test before they would let me write this book. But if I were unsure, I'd mentally exaggerate the height of the stack until it was much higher, far above my eye level, until the top tire was so far over my head that I'd get a crick in my neck trying to see it **(below center).** It would be clear to me then that what I'd see way up there would be almost certainly rounder

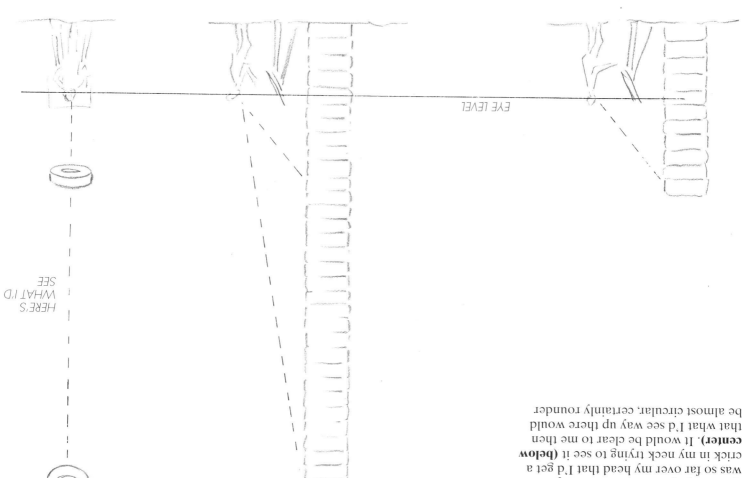

HERE'S WHAT I'D SEE

EYE LEVEL

than a tire down closer to my eye level. Not only would it clearly look rounder (that is, a fatter ellipse), but I'd see very little of its tread. If it were high enough, all I would see is its circular bottom and none of its tread. In other words, the higher a tire gets above my head (assuming it keeps level as it rises), the more I see of its underside and the less I see of its edges.

You can use the same trick in situations not really involving eye level. Earlier, when I was sketching the bridge and its arches, I was unsure how much space on the other side of the bridge I would see through each of the

arches – that is, would those little openings get progressively wider as they came toward me, or smaller, or would they stay the same? (I was not actually looking at a real bridge at the time.) So I imagined the bridge extending into the distance in both directions. It was immediately obvious that at some point as the bridge "passed" me on my left I would actually be looking through a totally open arch and that I'd see the whole world on the other side of the bridge through that arch. It was clear, then, that I'd see more through the near arches than the far.

Measuring Relative Sizes

It's important to keep measuring relative sizes of things as your drawing proceeds. In this view of the Capitol in Washington, D.C., that I dug out of one of my old sketchbooks, I had made a couple of notes to myself regarding dimensions.

The dome should be "more squat"; the width X should be about half again as wide as height Y. I simply used the pencil-and-thumb method described in Volume 1 to compare various distances.

I find that I have somewhat more need to check up on myself when I'm drawing rounded objects than when drawing rectangular things. The curves throw me off.

By the way, the little inset **(above right)** reminded me that I was viewing the Capitol through a break in some tree foliage. When I later painted the scene, I moved the building farther off-center to avoid too much symmetry.

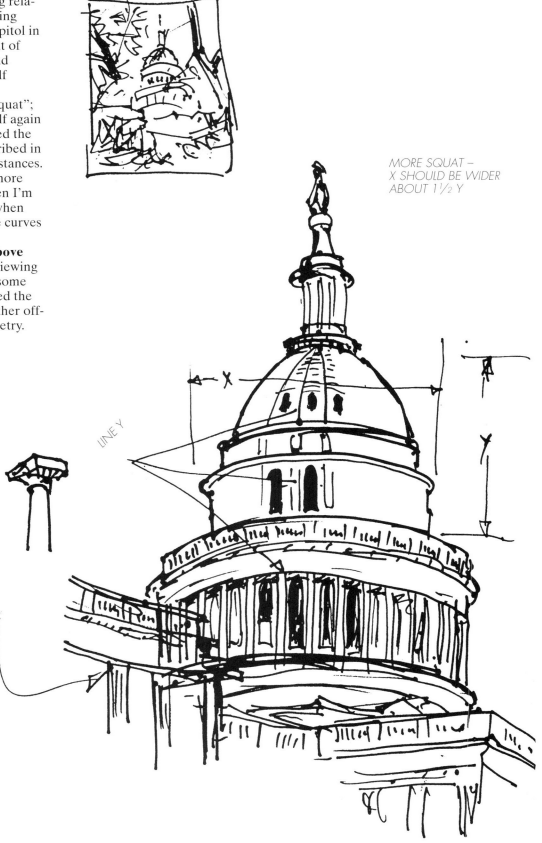

MORE SQUAT – X SHOULD BE WIDER ABOUT 1½ Y

Here's another case where I needed to make constant measurements. I marked the floor to remind myself where to return to whenever my drawing or painting of this still life was interrupted, because I was so close to the subject that every little shifting of my body caused me to see quite a different scene. (In a famous drawing by Dürer, an artist is seen drawing a nearby subject by closing one eye and keeping a pointed sighting stick directly in front of his open eye. The sighting stick is in a fixed position and cannot be moved by the artist. As long as the artist keeps his open eye precisely behind the point of the sighting stick, he knows he has not moved the position of his head.)

In addition to being careful about my position, I made sure the light source was not disturbed so that today's shadows would still be there tomorrow. And I constantly compared the heights and widths of objects against one another, all by the pencil-and-thumb technique. There are lots of surprises when you measure objects close to you in a still life. You think you know how big one thing is compared to another, but because you're so close, size differences become magnified.

This picture taught me that there's another way you can be fooled when you are drawing objects such as a decanter or wine bottle. The differences in the curvatures of the two ends of the object can throw you off. Let's say you're looking slightly downward at two items, a drinking glass and a wine bottle, as shown at **right**. In the glass, the curve of the bottom will appear more rounded than the curve of the top, because the bottom of the glass is farther away and its ellipse will be fatter than the top of the glass. That's fine as long as the top and bottom of the glass are essentially the same size. In the wine bottle, however, the top is much smaller than the bottom, and even though the bottom is farther away from you, its curve will appear less severe, less "rounded" than the curve of the top. If this doesn't make sense to you, try imagining a bottle whose top is a three centimeters circle and whose bottom is a one meter circle. No matter how you

view this bottle, the top will have the "rounder" curve. Observing such details can make the difference between a convincing picture and one that is unexplainably awkward. Exercises 6 and 7 offer ways of making such curves more accurate

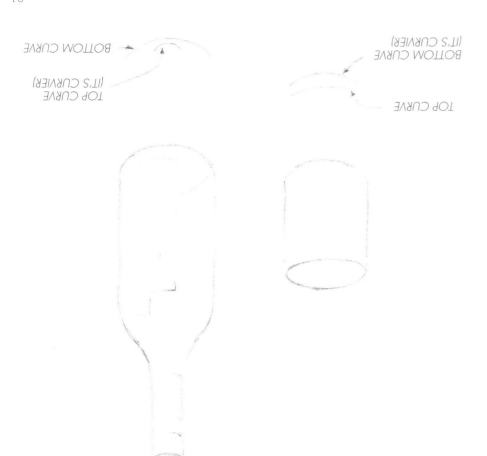

TOP CURVE

TOP CURVE
(IT'S CURVIER)

BOTTOM CURVE

BOTTOM CURVE
(IT'S CURVIER)

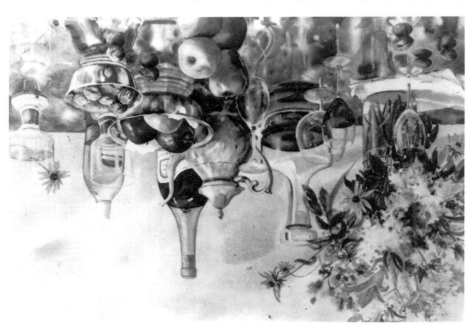

Reflections, Phil Metzger, watercolor, 86.3 × 111.7 cm

Exercise 6/**Checking Curves**

Find a curved object, such as a wine bottle, and set it up a few meters away on a table top. Imagine this bottle as part of a still life you intend to draw. The differing curves of its top and bottom can be a source of trouble. Here are two ways of checking up on whether you've drawn top and bottom curves correctly, relative to each other.

Method 1: Set up a piece of clear plastic and view the bottle through the plastic. With a grease pencil, draw the curve of the top of the bottle. Then, standing in the same position, move the plastic down so that you see the curve you've just drawn adjacent to the curve you now see at the bottom of the bottle. By thus comparing the curves, you'll know how to draw them on your paper.

Method 2: Sketch the bottle on your paper. Then cut a piece of scrap paper carefully to fit the curve of either the top or bottom of the bottle in your drawing. Hold the curved cutout at arm's length between you and the wine bottle and see whether the cutout curve matches what you see on the bottle. Change your drawing until you get a drawn curve to match the real thing. Then hold up the cutout and compare it to the curve at the other end of the bottle. Again, adjust your drawing to get the two curves right relative to each other.

Exercise 7/**Achieving Symmetry**

Drawing symmetrical objects and having them come out looking symmetrical gives a lot of us a headache. Here are two ways you can help get shapes right.

Be careful using such techniques. If you get too rigid and fussy, your drawing will be correct and boring.

Method 1: If you really want good symmetry, try this. Draw the bottle the best you can – just its outline. Then trace its outline on a scrap of tracing paper. Measure the distance between the two sides of the bottle and draw a line cutting the bottle in half from top to bottom. Fold the tracing paper along that line so that you'll see one half of the bottle laid over the other. Bet you a nickel they won't match.

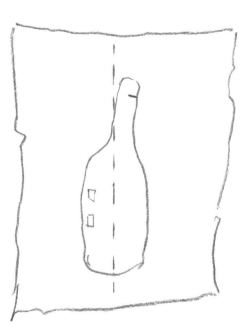
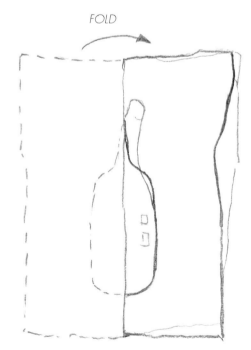

FOLD

Method 2: Get out the old wine bottle again (you've probably emptied it by now). Draw its silhouette. The rounded tops and bottoms of such objects give us trouble enough, but so do the rounded shoulders where the bottle's neck broadens into its body. Unless you're either lucky or gifted, your first shot at the bottle will probably not be symmetrical.

Turn your back on your drawing and look at it over your shoulder in a mirror held in front of you. You'll see your drawing in reverse and instantly spot deformities you never saw looking at it straight on. We have a psychological tendency to draw things with a certain directional bias, and seeing the drawing in reverse shows up that bias. You'll be absolutely dumbfounded, if you haven't tried this before, at the flaws that will show up in the mirror.

Actually, this works whether or not the thing you're drawing is a symmetrical object. Use the mirror no matter what you're drawing. It's particularly handy when doing a portrait. Many people have the tendency to get a face, for example, out of whack – one eye higher than the other, maybe. That sort of goof will instantly show up in the mirror.

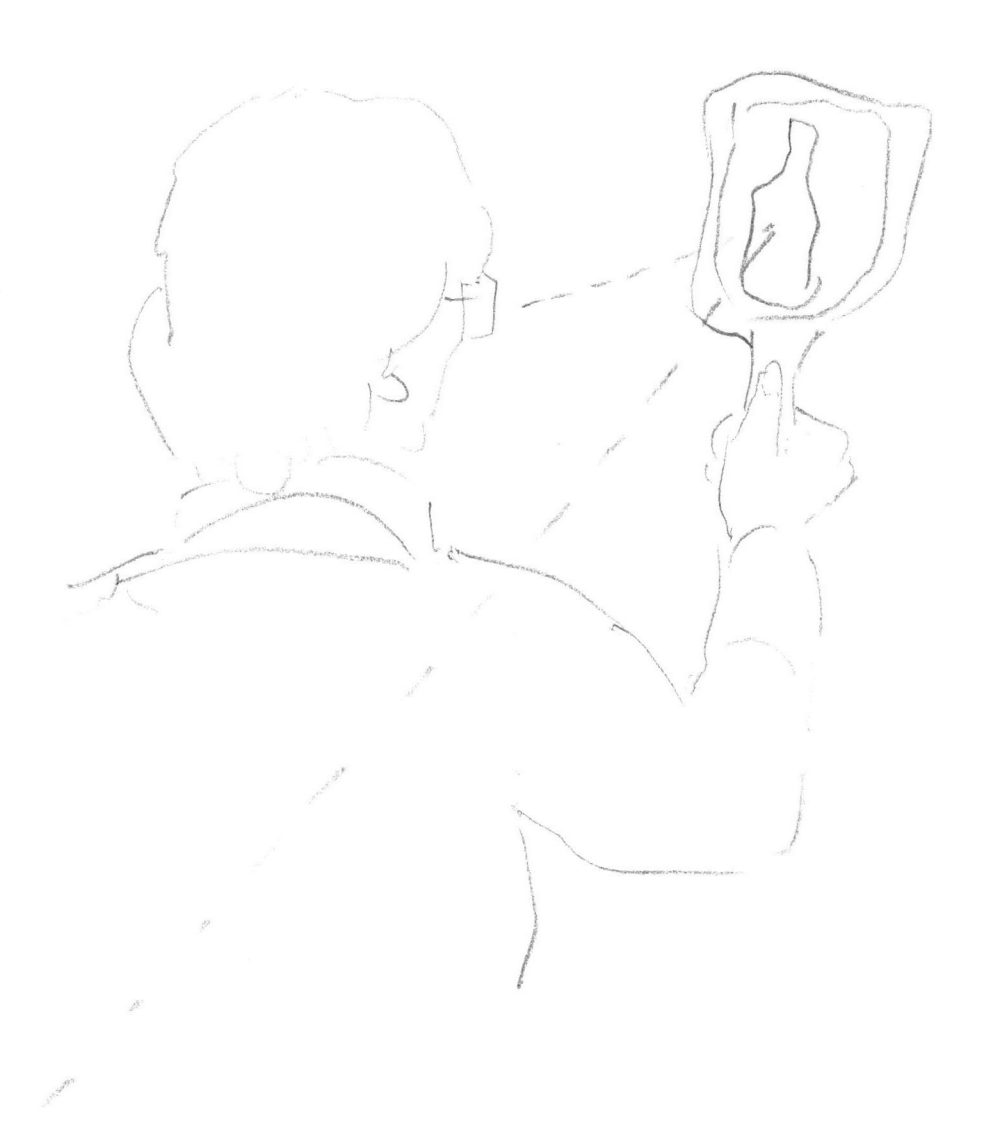

More Vanishing Points

In the first two workbooks we discussed pictures in which there were but one or two vanishing points. The truth is, friends, there are more vanishing points than you can shake a stick at. Luckily, we usually deal with only one or two, sometimes three. But it's important to understand that there may be more. Otherwise, one might be tempted to force every line in a picture to go to one or two vanishing points, with disastrous results.

We'll start with three. I've already show you lots of dinky little buildings like the one **below**, with two vanishing

points, one somewhere to the left and one to the right. We've so far let lines such as *a* and *b* seem parallel. Actually, though, they're not. Consider this: those lines are actually receding from you, are they not? Aren't they headed into far left outer space? Tilt a pad of paper the way the roof is tilted. Do you see that edges corresponding to *a* and *b* in the roof are headed away from you?

They are parallel lines, and our laws of the perspective jungle tell us that parallel lines receding from the viewer seem to meet, or "vanish," at a van-

ishing point. The difference between these lines and the other parallel lines we've dealt with is that these lines vanish at points not on the eye level. Only horizontal lines vanish at eye level. All these other queer lines vanish elsewhere. Let's find out where.

If you lay a straightedge along lines *a* and *b* and extend them to find where they meet, you'll get a drawing like the one **at bottom.** Where they meet (we'll call it VP3) is directly above one of the good old garden-variety eye-level vanishing points (in this case, VPL).

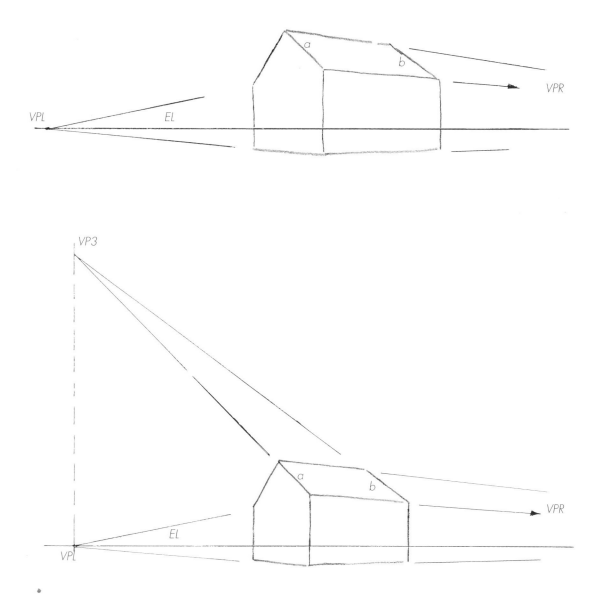

Very often we draw roof edges (such as *a* and *b*) so that they diverge rather than converge – and, of course, that's just not correct **(top right)**. It's not only not correct, but more important, it doesn't look right in the drawing.

The reason these lines so often get drawn as though diverging is that, thanks to an optical illusion, that's often what appears to be happening. If you hold up your pencil and compare the tilts of these two lines on a real building, you'll see that they *do* converge, as theory says they should; but when you simply look at the building with your naked eyes, they might indeed seem to diverge. The illusion is caused by the other lines and shapes nearby. What's important is that the drawing will feel better if you make these lines behave and come together out in space. No need to do any measuring or locating of vanishing points; simply use your straightedge and aim the lines slightly toward each other.

You've probably already guessed at where a fourth vanishing point might be. Yes, the edges of the other side of the roof (*c* and *d*) are receding and they vanish at a point directly below one of the eye level vanishing points, as shown **bottom right.** All these vanishing points would not line up in so orderly a fashion if our building were not such a perfectly symmetrical, humdrum little Monopoly-house.

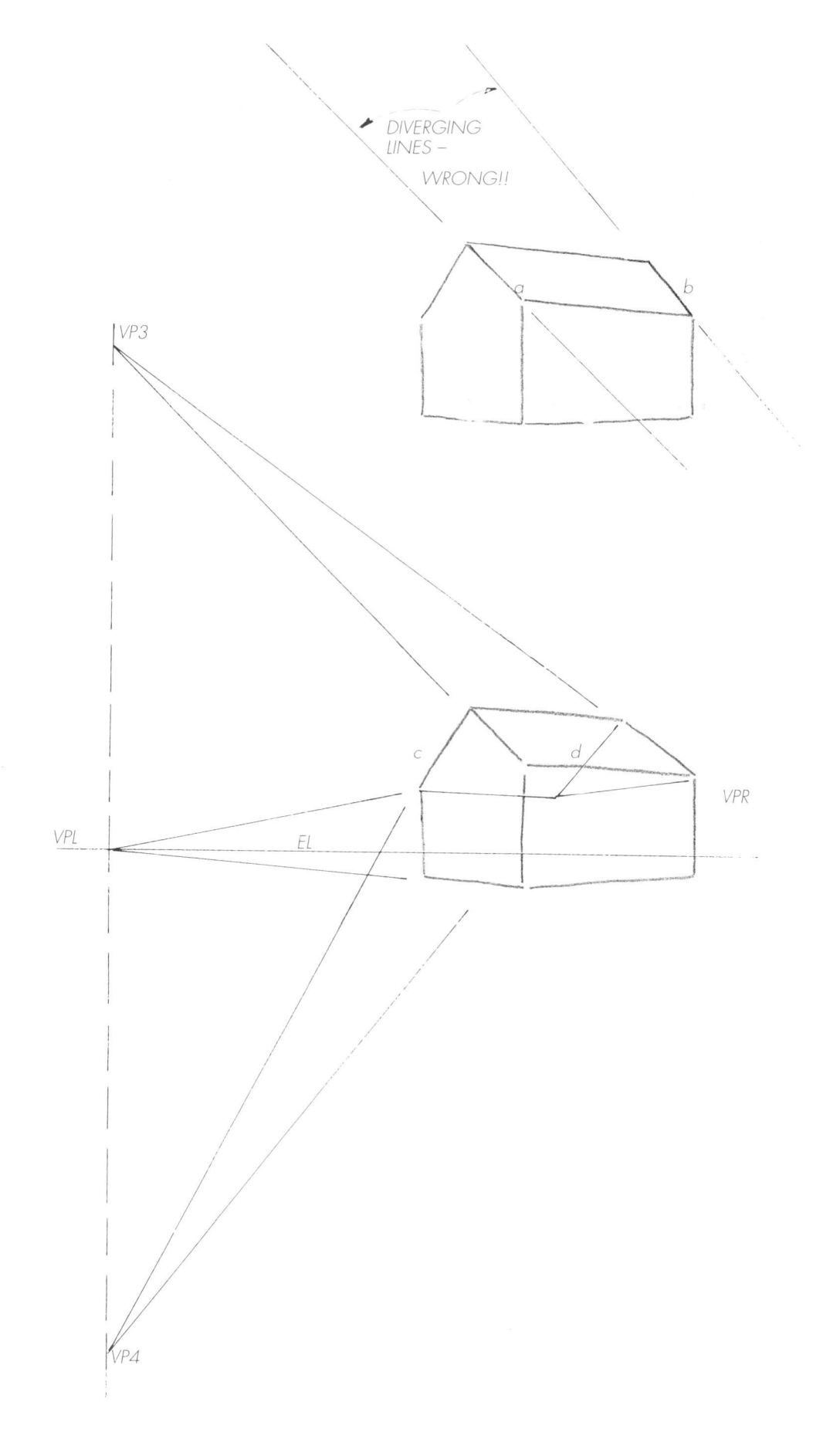

Some Vertical Lines Converge

There's a more important use of a third vanishing point than in these roof lines. So far, we've not molested the vertical lines in our buildings. We've left them vertical. That's appropriate if we're dealing with relatively low, squat objects, because all points along the vertical lines in such objects are nearly the same distance from our eyes. Those lines, in other words, are not visibly receding from the viewer.

Imagine you're drawing a skyscraper from a point on the sidewalk near the foot of the building. Assume it's a rectangular blob, not a tapered building. As you glance up at the building, instead of looking like a rectangular solid, it looks something like the drawing **bottom left**.

What you're seeing is the side edges of the building converging toward a vanishing point high in the sky. As you look up at the building, its parallel sides are moving away from you, and they seem to converge exactly as a pair of horizontal lines would appear to converge – only to a different vanishing point.

From a distance, say from another skyscraper's window, the scene might look like **bottom center**.

If you were in an airplane that same skyscraper would look more like **bottom right**.

The vanishing point for the vertical edges of this building is somewhere around China. Notice that our old friends, vanishing points left and right, are still with us, far out of the picture. You, in the airplane, have a very high eye level, or horizon. The entire city is below your eye level.

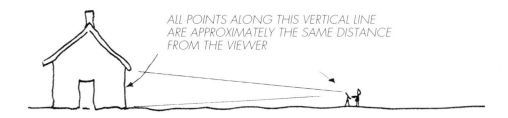

ALL POINTS ALONG THIS VERTICAL LINE ARE APPROXIMATELY THE SAME DISTANCE FROM THE VIEWER

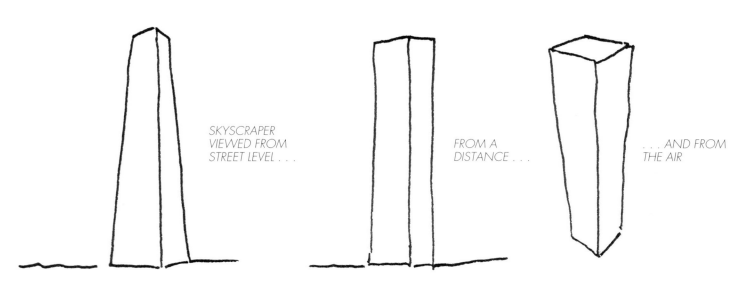

SKYSCRAPER VIEWED FROM STREET LEVEL . . .

FROM A DISTANCE . . .

. . . AND FROM THE AIR

The use of a third vanishing point may be important if you are drawing any high object, or a group of high objects, as in a cityscape. You might be depicting a scene like either of those shown here.

In both cases I've kept the third vanishing point fairly close to the subject and have gotten a distorted, bunching effect. If that's not what you're after, you need to raise the vanishing point much higher (or lower, if you're doing a view from an airplane). As in two-point perspective, the closer in you bring the vanishing point, the more distortion you'll get. If you want all verticals to stay vertical in your drawing, as things might appear from a distant view, go ahead and leave them that way – in that case there will be no third vanishing point.

Let's assume you're drawing a cityscape from street level. There are a couple of things to watch out for. First, most "rectangular" skyscrapers are not rectangular at all. Some of them are built with gradually tapering widths so that at the top floors the width of the buildings is smaller than at street level. That means that some of the apparent tapering you see as you look up from street level is real. In other words, those tall "vertical" edges aren't really vertical. This tapering could throw you off if you're unaware of it because the third vanishing point for a tapered building will be lower than the third vanishing point for an untapered building standing right next door. If all the buildings in your scene were truly vertical (no tapered sides), they would all share the same third vanishing point.

Second, each skyscraper has its own set of left and right vanishing points, just as any other building would have. They both lie on the eye level.

I said earlier that there are billions and billions of vanishing points. The number actually is infinite. Although you'll rarely be concerned with more than three, it's enlightening to know that for every pair of parallel lines in a scene there can be a different vanishing point.

The important things to know about vanishing points, especially those not on the eye level, are (1) that they exist, and (2) roughly where they are.

Knowing just that much will remind you to draw lines heading toward those vanishing points with an appropriate amount of convergence.

Knowing, for example, that the slanting roof edges of our Monopoly-game house really do converge toward a vanishing point will stick in your mind and prevent you from making the common error of drawing diverging, rather than converging, lines. You need never actually find the exact location of that vanishing point. It's usually enough to know that it's "right about here at the upper left."

TO VP3

TO VP4

27

Locate at least ten vanishing points in
this scene. An answer diagram is
supplied on the **next page**.

9

5

TO

EL

1 2 3 4

7 8

11

6

12

THESE TWO VANISHING POINTS ARE
FOR THE FAR SIDE (THE HIDDEN SIDE)
OF EACH ROOF

13

This answer diagram shows thirteen
vanishing points for this scene. Note
that it assumes that short vertical lines
are left vertical and not given vanish-
ing points.

Exercise 9/**Roof Edges**

Correct sloping lines *a*, *b*, *c*, and *d* on
these structures freehand. When
you're finished, use a straightedge to
make sure that the new lines you've
drawn slightly converge toward their
partners, *a'*, *b'*, *c'*, and *d'*.

WRONG!

RIGHT!

a'

a

d

c'

d'

b'

c

b

29

Here is a simplified water tower seen from a distance by a viewer standing on the ground. Using the practice spaces on the next page, loosely sketch the tower from the same eye level, but closer to the tower, so that you would have to tilt your head far back to see the top.

Hints:

1. You might start with the platform on which the tank rests, since it's the only thing in this scene that's a good old rectangular solid. One version of how the platform might look has been drawn in on the practice page.

You may use this as a starting place. It's drawn in one-point perspective. By extending the left and right sides downward you can find the vanishing point. A horizontal line through that vanishing point is, of course, the eye level. Now build everything relative to that eye level.

2. You can place the tank on the platform properly by locating the perspective center of the hidden top of the platform. The tank is cylindrical, its sides vertical. Above your head it would look something like this if you could see it without anything else in the way.

3. Do plenty of "drawing through." Show the conical top through the tank, the tank through the platform, etc.
4. How about the cone of the top? Whether it will be visible in your view depends on (a) how close you are standing to the structure, and (b) how high the cone and the tank actually are. Some possibilities are shown.
5. Assume the legs and braces are all round pipes with no actual taper. (They'll taper some, of course, when shown in perspective.)

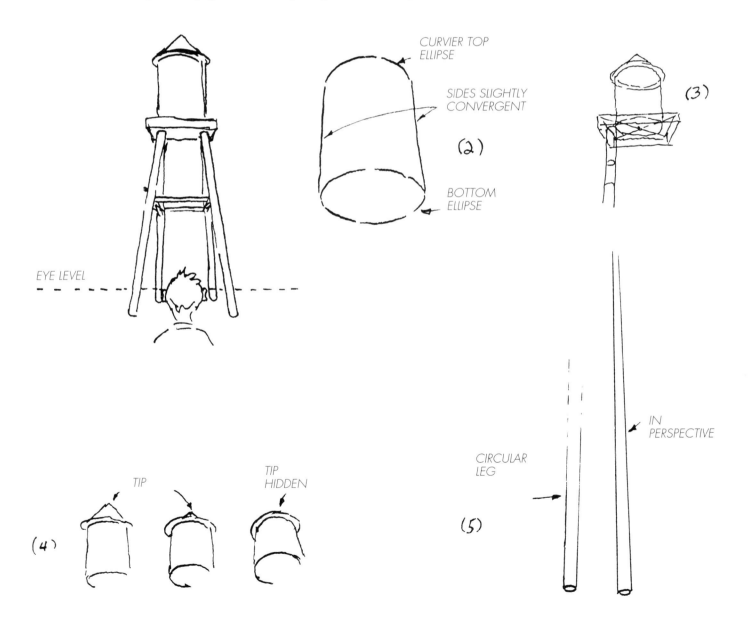

Practice Space

Inclines

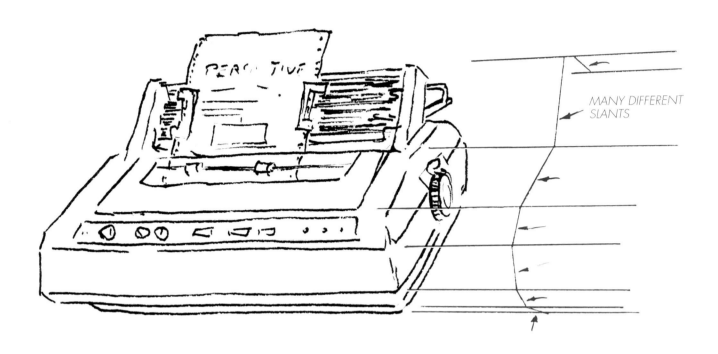

MANY DIFFERENT SLANTS

I'm inclined to think there are slanted surfaces everywhere you look. Next to me is a printer with a couple of slants **(above)**.

Down the street at the shopping center are sidewalk ramps **(below)**.

And then there are the sloping roofs of houses and barns, lots of tilted roads and streets, fields that don't lie level, and a great variety of stairways. Including inclined surfaces in a drawing very often provides the spark that

revives an otherwise comatose picture. Inclines sometimes bedevil the artist, but they're not so hard to do if (you guessed it) you start off with plain, old-fashioned linear perspective.

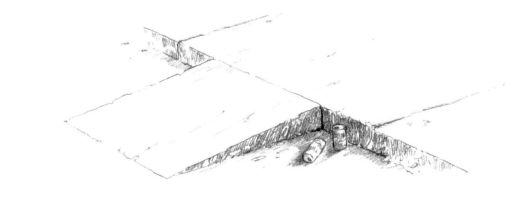

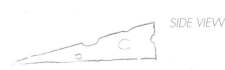

SIDE VIEW

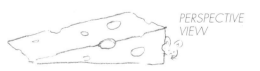

PERSPECTIVE VIEW

The simplest kind of incline is a wedge-shaped object that looks like this when viewed from the side.

That same incline looks like this when seen in perspective.

The wedge also can be seen as half a rectangular box.

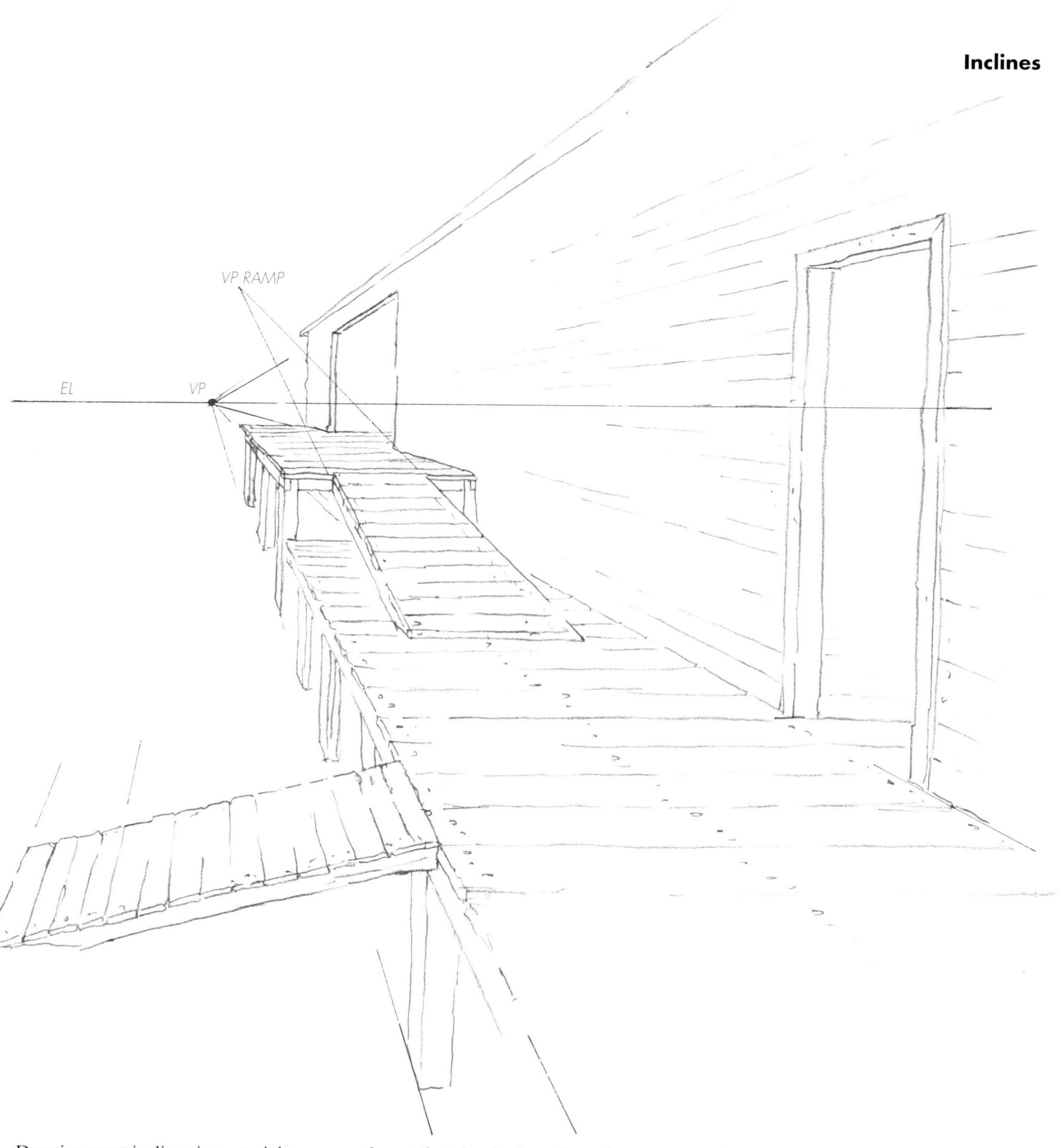

Drawing most inclines is as straight-forward as drawing the sloping roof of a house – something we've already covered. If you forget about the sloping lines for the time being, and first draw (in perspective) the rectangular shape into which the incline will fit, then you can easily slice the rectangular shape in half, erase the part of the rectangular box you don't want, and what's left is a wedge shape. Don't

forget that the sloping edges of an incline will have a vanishing point, provided the incline is actually of uniform width.

Here is a combination of inclines at a loading dock. I've drawn the building and the platform in one-point linear perspective (remember Volume 1, Part 1?). The vanishing point to which all *horizontal* receding lines retreat is VP. It's on the eye level. The distant ramp,

however, is not horizontal, not parallel to the ground, so its vanishing point is not at eye level, but, in this case, above it at VPramp. The boards in the nearer ramp recede to VP because they are ordinary horizontal lines, each parallel to the ground. The side edges of this ramp don't have a vanishing point because all points along either of these lines are, for practical purposes, equally distant from the viewer.

Construct a ramp going from level A to level B and a second ramp from level B to level C. Make their widths approximately as indicated by *w* and *w'*, and their lengths whatever you wish.

Hint: This scene is drawn in one-point perspective, with the vanishing point at the upper left. Locate the VP. Then construct two rectangular boxes, one fitting up against *w* and the other fitting against *w'*. When you slice a wedge from each of these boxes you'll be left with something similar to what is shown **above right**.

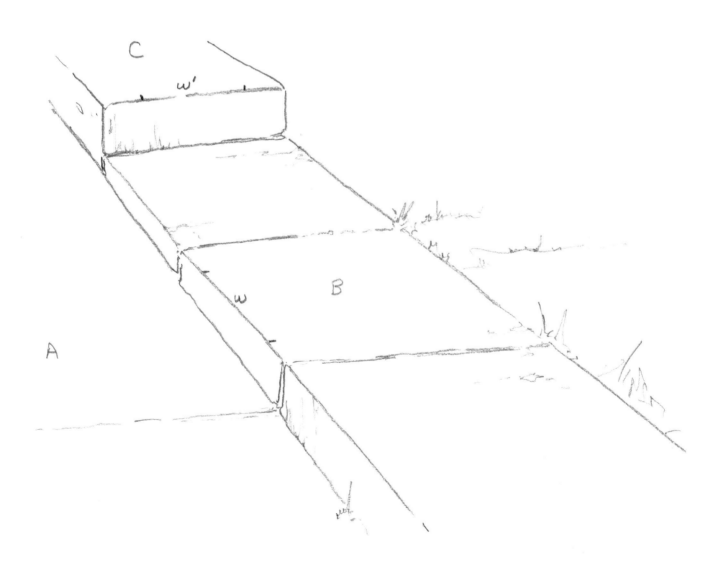

Roads, Paths, and Streets

Although a road or path leading up to a building may seem a minor part of a picture, properly done it can be very effective in suggesting depth in the scene and in describing the flatness or hilliness of the landscape. **Below** is a scene with no obvious means of getting to the house, built by the bozo who did my house, no doubt. **Below that** are three alternative paths one might use to lead up to the house.

Take a small piece of tracing paper and trace the lines of the three paths. Overlay the house sketch with the first path. It's clearly not effective. It suggests that the path has the same width all the way, which in turn suggests that the path is vertical to the viewer's eye – either that or this house sits on a cliff and the path is really a ladder to get up the cliff!

Try the second path. It has what the first path lacks: linear perspective. Using this path, one would conclude that the ground leading up to the house is more or less flat. This path introduces depth.

Try sketching a similar path, but one that does not appear to broaden quite as much as the second path – a path somewhere between the first and second examples. Notice that narrowing the path tends to make the distant house feel more as though it's on a rise and the path is climbing upward to get to the house. The extreme of this, of course, is the first path, where the hill leading up to the house indeed seems to be very steep. The more you broaden the path as it comes forward, the more the land seems to flatten, up to a point. When the broadening

becomes too pronounced, the perspective will simply seem exaggerated. You need to play with various widths to find what feels right.

The paths we've considered so far are pretty rigid. That might serve well in some pictures, but often you'll want to introduce some zigzag in the path to effect more interest. Overlay the scene with the third example. What we find here are a couple of perspective techniques at work. Not only are we using linear perspective, as in the second example, but size variation, as well. The path can be thought of as a series of segments having similar shapes, but decreasing in size as they recede **(bottom)**.

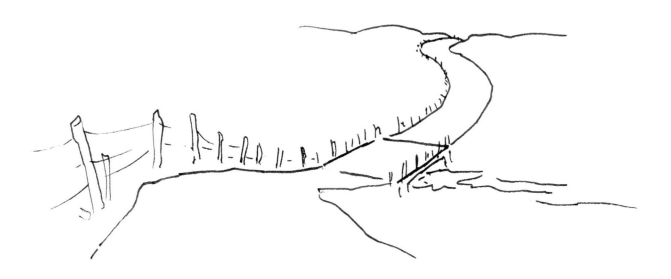

Another effect of the zigzaggy path is that it pulls the eye into the picture along a more scenic route. The straight path just zaps you right up to the house, no fooling around along the way.

Paths, roads, and streets are effective elements in conventional landscapes. They provide a thread around which buildings and other elements may be woven; they offer an easy means of suggesting depth; and they provide a terrific means of focusing attention. Drawing them is sometimes tricky, but if you'll think of them as thin slabs in perspective and be aware of the tilt each segment might have, the drawing will come more easily. Study what's happening in the scene **above**.

Think of this road as comprising several segments, 1, 2, 3, and so on through segment 7 **(below)**.

I've shown perspective lines (they're only rough approximations) and vanishing points for some of the segments. Segment 3 appears to be fairly horizontal as it spans a bubbling brook. It can be seen as a rectangle having its vanishing points as shown. Segment 1 is also roughly level; we know this because its vanishing point (it happens to appear in one-point perspective) lies on the eye level. The remaining segments are inclines having vanishing points above or below the eye level, as in the case of roofs we discussed

earlier. Estimate for yourself where the vanishing points for segments 4 and 5 might lie. You'll find them quite high above the eye level.

If you have a problem making a road (or path or street) do what you want it to do, try visualizing it in rectangular segments, some of which may be inclines. Draw in the level, establish very roughly where the vanishing points might lie when the sides of the segments are extended, and vary the positions of these vanishing points to get the degree of tilt you want. But as always, sketch first and resort to vanishing points and construction lines only to help solve problems.

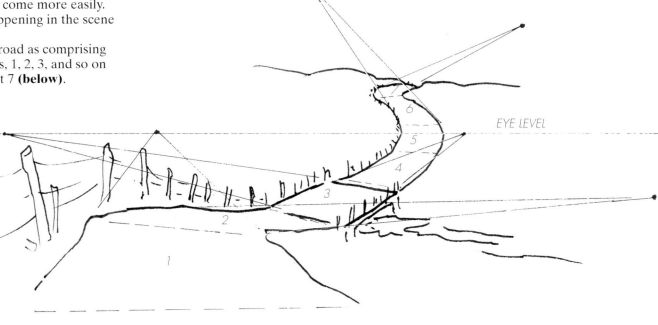

Often the effective drawing of a road or street depends on clues other than the lines representing the edges. We just discussed the value of gradually diminishing sizes of segments as a zigzagging road recedes. Another effective perspective technique is to pay attention to details of things along the road. **Above,** for instance, the fence posts and utility poles do more to define the road than the lines of the road itself.

If you look closely you'll see the tops of the posts beyond the hill – they tell you that the road dips as it goes over the crest of the hill and that it turns some toward the right. Some subtle detail can be more interesting and enlightening than a ton of more obvious information.

One more example. In the sketch **center right** we know there is a down-hill segment of this road that is invisible in this view. How do we know? The discontinuity between the nearest road segment and the more distant segment tells us. The fact that width b is so much less than width a tells us that something sneaky is happening between a and b, and intuition in what that something must be. The fact that the distant segment is also out of line with the near one helps, too, but even if the segments were all neatly lined up as at **bottom right,** we'd still know we were looking at a roller coaster road.

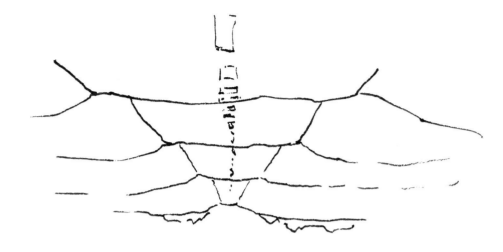

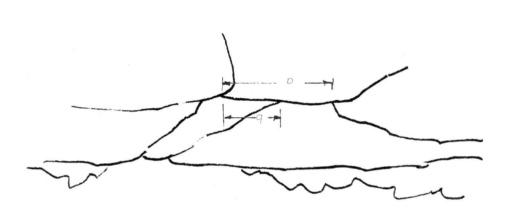

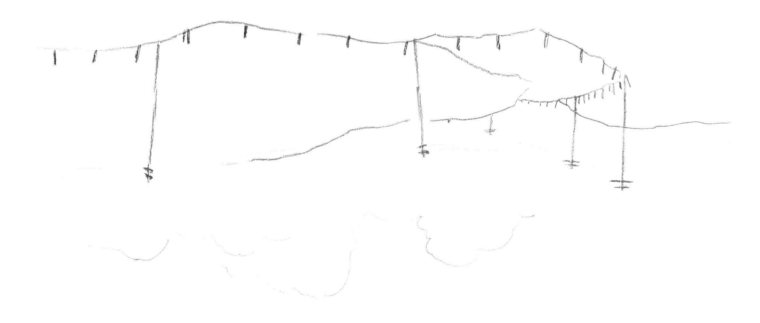

Here are several paths, any one of which might be used to lead up to the house. Using erasable soft pencil or charcoal, place each of these roads in the scene to get a feel for some of the options you have. There is no "correct" answer, only a variety from which to choose. See what each choice does for the feeling of depth in the picture.

If you were to paint flat country fields, you might have something like the drawing at **top right**.

On rolling terrain, plowed furrows or rows of corn will follow the curves of the ground and maybe you'll see a scene like the second drawing at **bottom right**.

You can find all kinds of perspective in such scenes. You will see rows of corn or plow marks getting closer together in the distance, just as linear perspective says they ought to; near stalks are tall and distant ones are pipsqueaks; near stalks are full of luscious detail, distant ones fuzz and blend together; near ones are strong-colored greens and yellows and browns, distant ones are paler and cooler. It seems that such fields really are putting on a perspective show for us! If you can get out and sketch such seemingly simple scenes, you'll learn a lot about perspective.

There are some things you'll observe in these scenes that, if copied exactly as observed, may not work in the painting. Often, for example, there will be a nearby field of very strong blue-green (a field of rye, perhaps) and in the distance strong warm colors (newly plowed earth, ripe hayfields). The pattern of colors may look great out there, but on your canvas the warm distant colors may scream to come forward and the cool nearby colors may retreat into the background.

Such apparent anomalies occur all the time. Don't be bound by rules such as, "Warm colors advance, cools recede." Sounds like a military marching order. Only use the "rules" as guidelines to help smooth over problems. If the colors aren't working on your canvas, then take whatever liberties you must to make them work, but don't blindly interchange the green field with the yellow one! Simply play with the colors gently until they no longer complain. Maybe all you'll need in this example is to warm up the green a little and dull the yellow.

It may be that you can leave the colors alone, but play with the other perspective techniques you know and use them to help get the depth you want, ignoring the apparent inconsistency between the forward cool area and the distant warms. It may be that including fence posts whose sizes diminish rapidly as they go back into the picture, or trees or hedgerows that do the same, will help a lot. And detail up close, fuzziness in the distance, will certainly help. You may even have a strong layer of clouds overhead which you can paint as progressively smaller blobs as they recede into the picture. Add to this some overlapping objects, and pretty soon you'll have a picture whose color reversals are inconsequential.

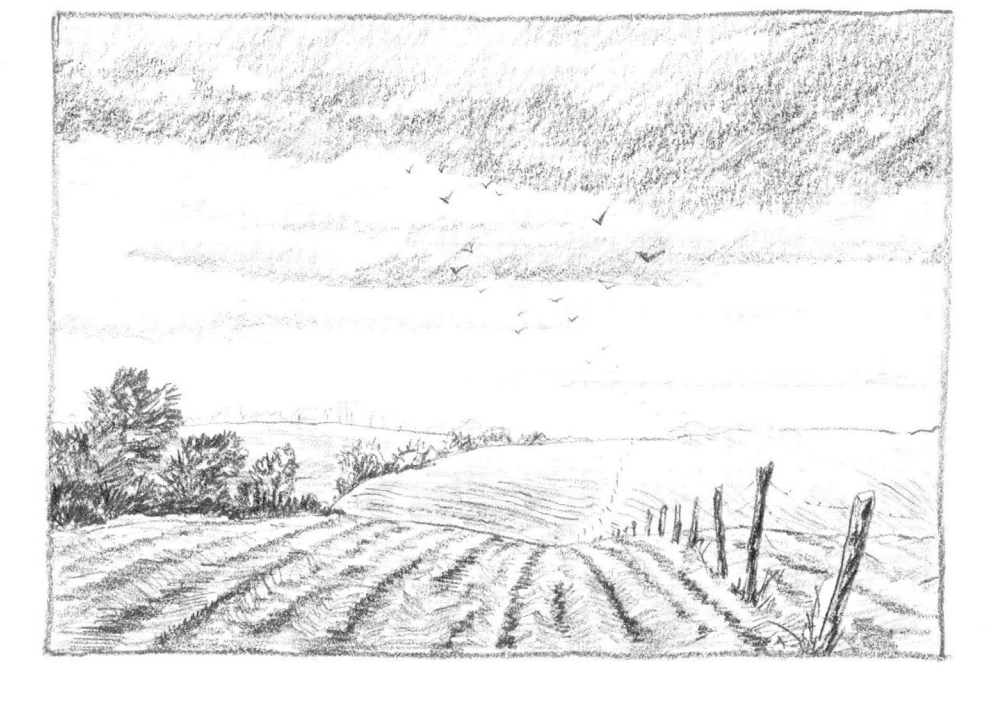

Fields and Streams

Sometimes you'll have a stream meandering through your fields. You can pretty much treat a stream as if it were a road on flat ground, with appropriate curves or zigzags, but with a width more likely to vary than that of most roads. If there are rocks or wavelets or other details you want to include, make the nearer details more evident than the distant ones, just as you would draw anything else. There is one caution I would mention: bodies of water, other than falls or rapids, are flat. You can enhance their flatness by a few well-placed *horizontal* strokes, as **below** but you may have to invent some of these horizontal strokes. If you paint too many of the actual ripples you see, as at **bottom**, and they are not horizontal, you may destroy the feeling of flatness. This is one time when painting faithfully what you see may not be a good idea.

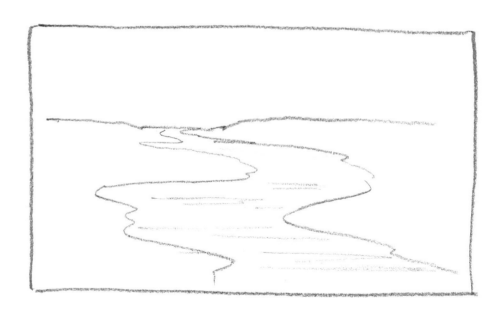

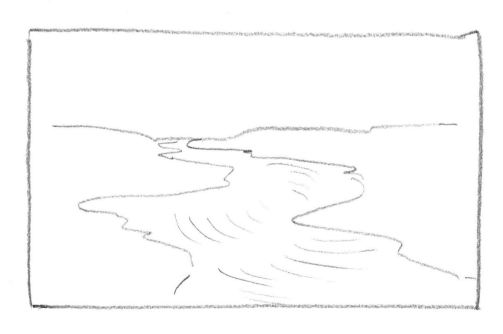

Stairs

Stairways look complicated, but basically they are a variation of a simple incline which in turn is a rectangular block sliced diagonally in half **(below right)** like the cheese wedge in an earlier sketch. **Left** is a basic set of stairs.

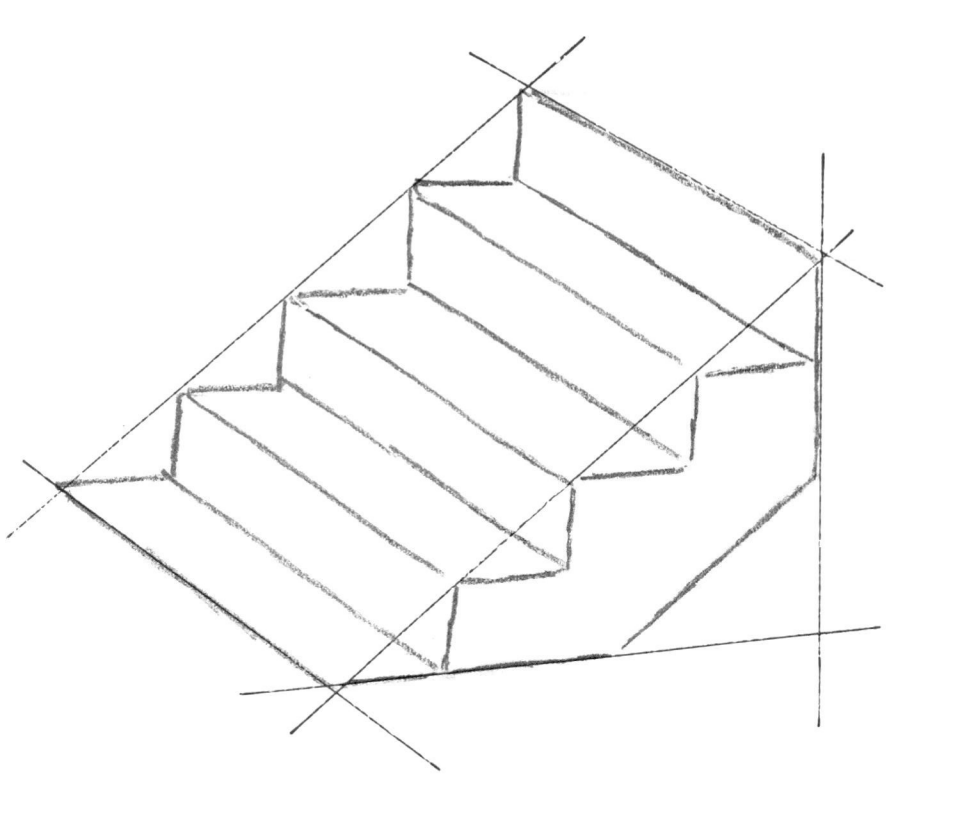

Stairs

This is a sketch that I intended to work up as a finished drawing, but never did. Everything sagged in the old Harper's Ferry building, and its linear perspective is far from perfect. My eye level was about in the middle of the right-hand steps. The upper landing sagged so much that instead of seeing slightly up under it, I could see the tops of its boards.

I'll take you step by step through the process I used to draw the stairs in this scene.

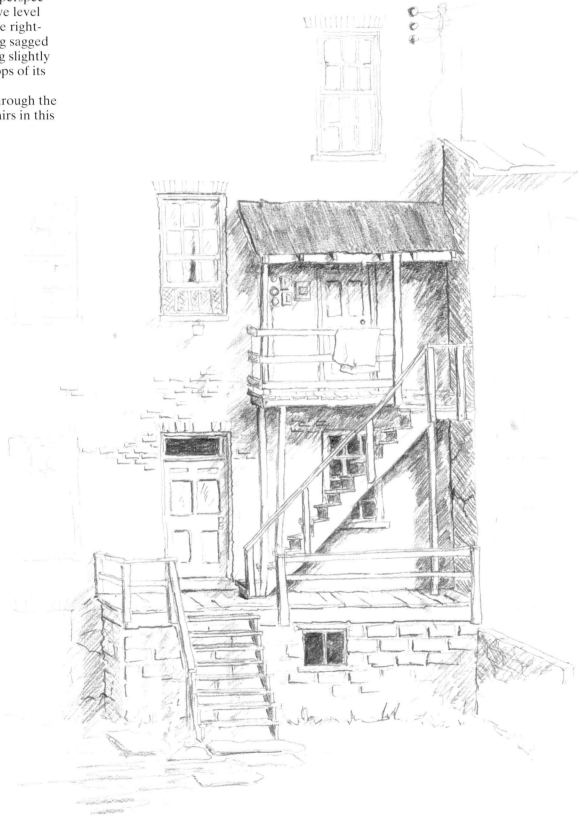

Figure 1.

To draw the higher set of steps, I didn't draw a wedge, or incline, in perspective, although I kept such an image in mind. What I drew first were a couple of light lines representing the direction and outer bounds of my steps, as in **Figure 1.**

Those lines kept my stairs aimed in the right direction and defined the area they would occupy on the drawing. Then I drew in essentially horizontal and vertical lines showing the shape of the near side of the stringer (the long sawtooth-shaped support for the steps). This located all the individual steps **(Figure 2).**

Next I drew the "horizontal" lines for the top edge of each step **(Figure 3).** Then I added the vertical far edges (the sawtooth shape on the other side of the steps — **Figure 4).**

After that it was a simple matter to add the step thicknesses and to tilt the steps gradually as they descended below my eye level.

Below is another set of steps I painted with conscious attention to perspective. I've overlaid the painting with a few perspective lines. Notice, first, that in a subject such as this, things sag and perspective is not perfect. It's enough that the right and left slants of appropriate lines are generally correct.

The set of steps in the picture is adjacent to the shed, and, if built "correctly" and not ravaged by age, would share the same vanishing points as the shed. Indeed, if you project lines far enough to the right, they do seem aimed toward the same vanishing point, but left-leaning lines do not. The lines I've shown headed left from the steps meet the eye level roughly where the old tree stands at the left of the picture. In a proper structure, however, those lines would meet the eye level much farther left, in fact at the same point as the line from the roof edge, line a. The fact is, the steps have sagged (haven't we all), and furthermore, they weren't made all that perfectly in the first place.

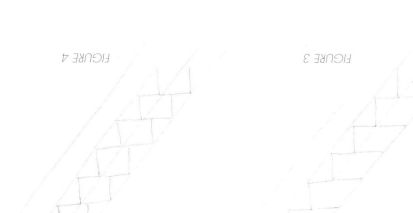

FIGURE 3

FIGURE 4

FIGURE 1

FIGURE 2

There are a couple of other perspective techniques at work here. The detail around the center of the picture helps focus the eye there: the suggested path, wider in the foreground than at the steps, leads the eye to the steps; there is some fuzziness in the distant background: the sudden change in value at the doorway makes the inside of the shed seem deeper, farther away, than the face of the shed; and a good many objects overlap one another and push each other back.

Farmyard Steps, Phil Metzger, watercolor, 71.7 x 91.4 cm

Here's an exercise showing one way (there are many different approaches) of drawing steps. If you'll do the exercise along with me by following the approach I've outlined, I think you'll find the construction not all that baffling. I wouldn't want to kid you, though – drawing a set of steps to fit a particular space (the kind of job an architect might face) can be tricky. But it can also be fun. If you understand the basics of linear perspective presented in these workbooks, you can figure out most step problems. If you get into weird situations involving, say, circular stairways, things get much more complicated, but even there you can build your steps within perspective cylinders.

Use the worksheet on **page 47** and follow along with me. The job is to draw a set of stairs between line *a* and the doorway on the raised floor. This is an approximate method. There are books full of exact architectural methods for building stairs, but that's not our interest here. You know the old saying … "good enough for government work!"

Start with the knowledge that the width of the stairs at the top is *b*. Since the top of the stairs will be a little farther away from you than the bottom, *b* should be a little shorter than the foot of the stairs. How much shorter? Drop vertical lines from each end of *b* to the floor. Where those verticals hit the floor, follow the floorboard lines out to *a*. Where the two floorboard lines chop off *a*, you have the width and location of the foot of the stairs. (You realize, of course, that the floorboard lines go to the left vanishing point).

Lightly draw the two lines between *a* and *b* which define the incline, or wedge shape, of the stairs.

Decide how many steps there are to be. We'll assume it's eight, including the top step at *b*. Divide one of the verticals you drew earlier into eight equal parts.

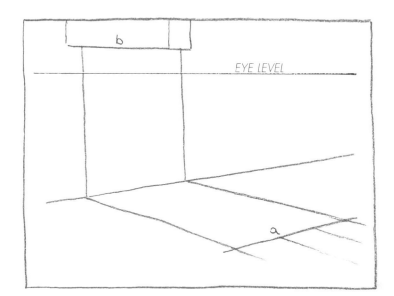

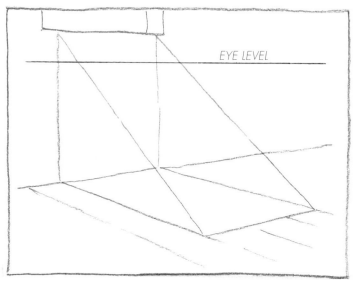

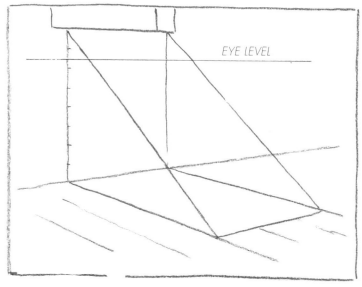

Draw light construction lines through these points toward VPL. Now we have the slopes of the steps.

Draw construction lines from VPR to the points where the slopes of the steps hit the incline of the steps. Now you have the front edge of each step.

Draw the short vertical lines defining the near end of the risers (the vertical pieces between steps). Darken the resulting sawtooth shape.

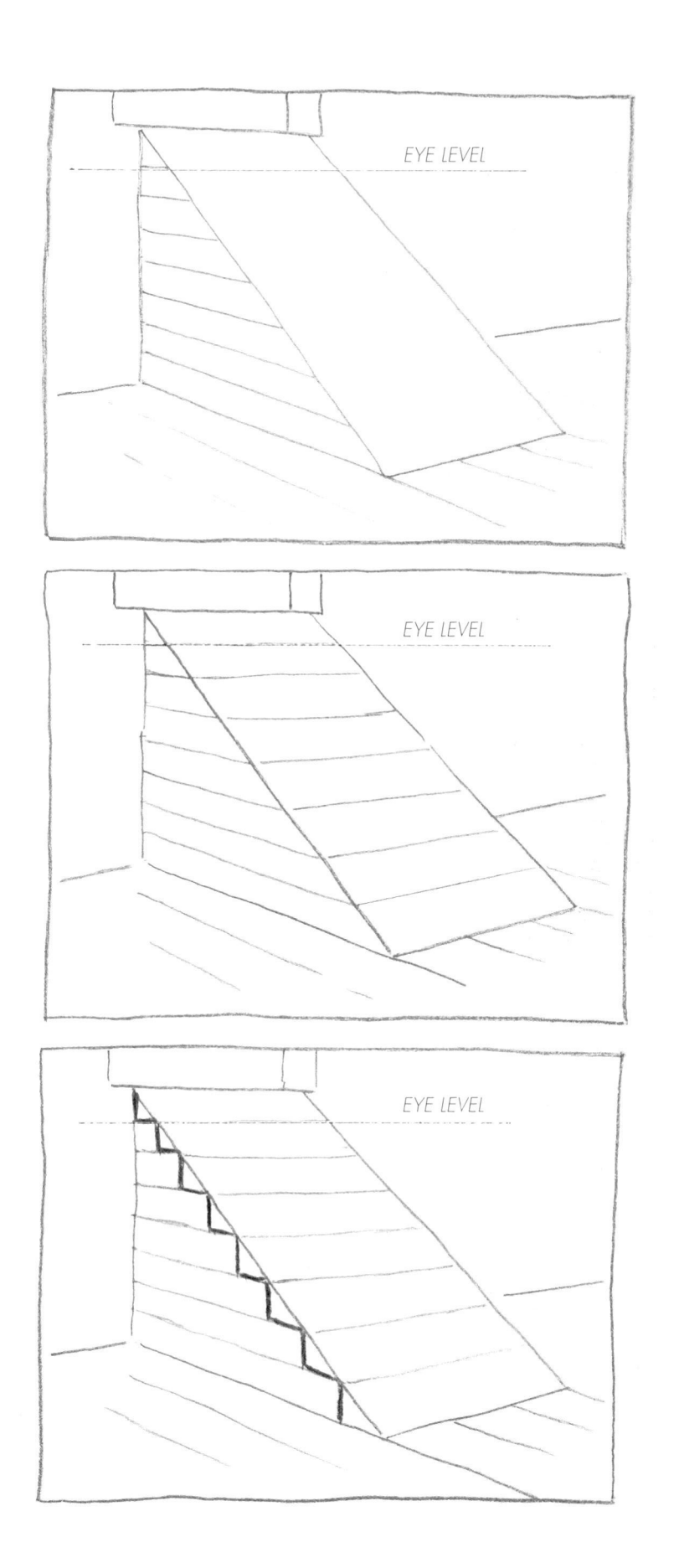

Draw lines to VPR from each of the low points on the sawtooth. Those lines define the rear edges of the steps. Drop short verticals to mark the right-hand edges of the risers.

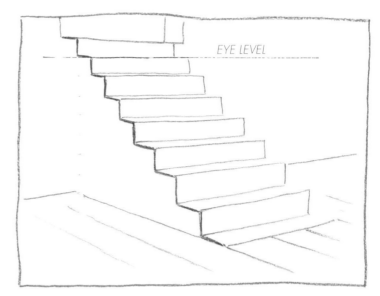

Complete the right-hand sawtooth with lines drawn to VPL.

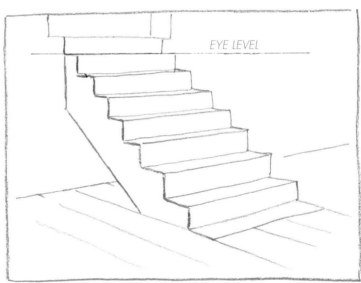

The basic stairs are complete, ready for details. These details can easily be done freehand, but as you see, they still follow the rules of perspective, the siren calls of those sexy vanishing points!

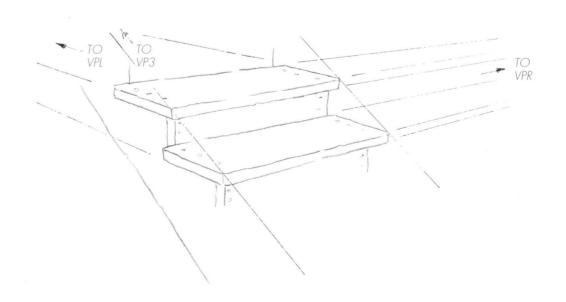

For directions, see **page 44.**

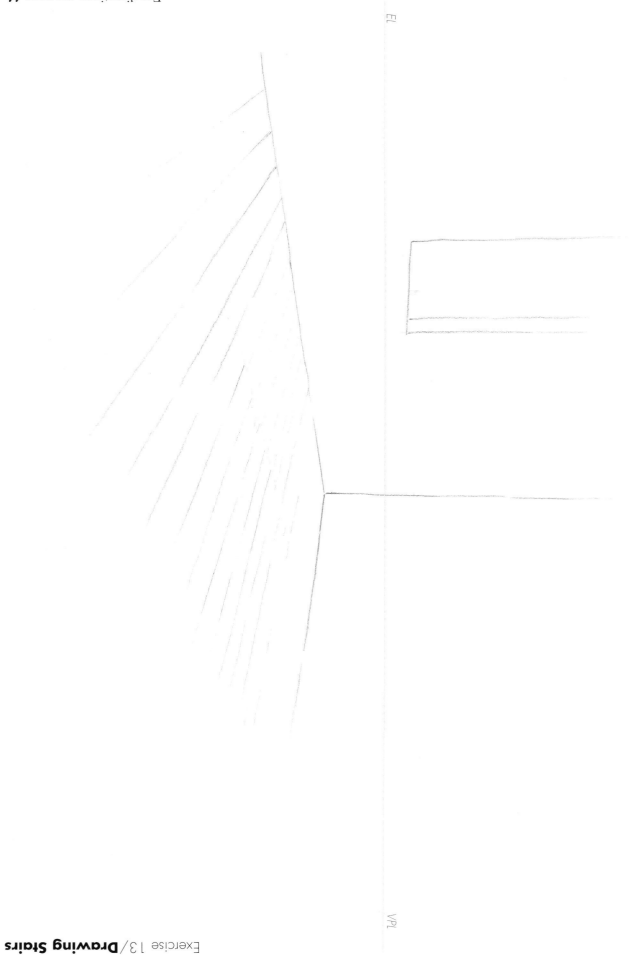

EL

VPL

Exercise 13/**Drawing Stairs**

Hit the Streets

In this street scene all the perspective techniques we've discussed come into play.

This kind of scene is a lot of fun to do, and even a sketchy rendering such as mine makes you dig deep into your bag of tricks. Try sketching some street scenes, even if that's not the kind of art that grabs you. The exercise will tone your drawing muscles.

Don't set out looking for just the right scene, though. Set up your easel anywhere you won't get run down by a truck and start drawing. Most of us look for a scene that's "just right" and never find it, but spend the whole day looking. Instead, find a scene you're moderately happy with and then fix it as you draw.

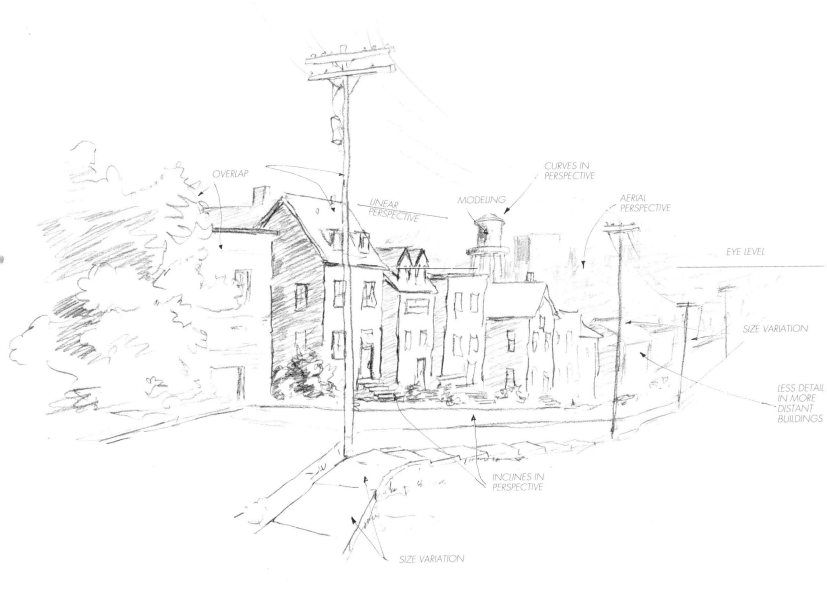

OVERLAP

LINEAR PERSPECTIVE

MODELING

CURVES IN PERSPECTIVE

AERIAL PERSPECTIVE

EYE LEVEL

SIZE VARIATION

LESS DETAIL IN MORE DISTANT BUILDINGS

INCLINES IN PERSPECTIVE

SIZE VARIATION

Volume 2/Part 2
Putting It All Together

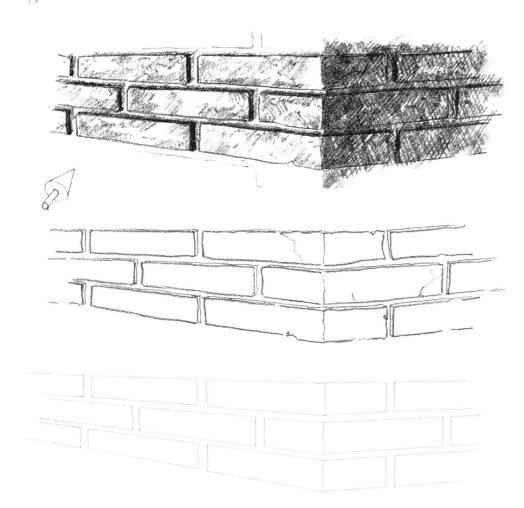

Introduction

The first three sections of these books have covered all the basic perspective techniques you might need in the fine arts. As you have seen, the technique called linear perspective heads the list, but the other techniques — overlap, size and space variation, modeling, detail and edges, and color and value change — are also important and effective. In this section we tidy up a few loose ends. Some of the topics here elaborate on techniques already discussed and show how to apply those techniques to more advanced problems. Other topics, such as shadows, reflections, and refraction, might be considered secondary perspective techniques — they sometimes affect the illusion of depth, sometimes not — and so they are briefly treated here. And finally, we offer reminders of common errors in perspective and some cautions about the limitations of the use of perspective techniques.

Materials

The things you'll need for this work-book are some pencils (2B-soft, HB-medium, and 2H-hard will suffice), or charcoal if you prefer; some tracing paper; a straightedge; a flat mirror at least 30 cm² in size; a flashlight; a spray bottle; cardboard; scissors; and a few other odds and ends.

Details, Details

Most of the time when we discuss the illusion of depth in our pictures, there is the implication that we mean quite measurable depth — miles, perhaps, or at least feet. But there is another way of looking at the notion of "depth." Instead of thinking always in terms of big distances, think about the solidity or three-dimensionality of a subject. If you can make a subject look three-dimensional, even if one of the dimensions is only an inch or two, you will have emphatically strengthened the illusion of depth on your flat picture surface. A significant way to achieve this feeling of solidity, this third dimension, is by including in your picture appropriate detail, as I'll demonstrate in the following examples.

Bricks

The **top** drawing below shows some bricks in linear perspective. Notice that they are drawn according to the basic rules of linear perspective you've already learned: Right-slanting lines meet at a vanishing point to the right, left slanting lines meet at the left, and short vertical lines remain vertical.

Suppose we embellish the bare sketch with some detail. Draw along with me right on the first sketch. First let's get rid of the ruler-perfect edges. Real bricks just aren't so neat. They usually have imperfect edges, cracks, and chips.

Next we need to show thicknesses. Bricks are laid in mortar in a variety of ways. One of the most common is with the mortar slightly recessed.

Now let's add some texture and settle on a light source (**bottom**). I've chosen a source at the upper right, so the shadows I get are cast to the left and underneath each brick. The entire left wall, where the bricks turn a corner, is in shadow.

By the way, when you're establishing the values (lightness or darkness) of two adjacent areas like this bricked corner, it's usually helpful to make the dark side darkest near the corner. This emphasizes the value contrast that happens at the corner, and helps create a stronger illusion of a break, which in turn enhances the feeling of depth. This extra darkening where the two edges meet is not just a ploy to get more depth — it's actually how we see such a situation. The dark edge next to the light edge seems darker than it is because of the contrast with the light edge.

Details

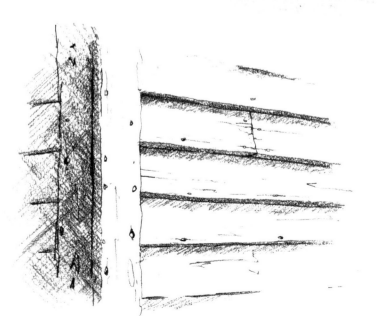

CUTAWAY VIEW
OF BEVELED
SIDING

Details

You can see that including a little detail can inject life into some dull objects. You don't need to be working close to the subject, however, to get results. Suppose you're drawing a brick wall from a distance and you're confronting it squarely, not at an angle. Your basic bricks may look like the drawing **above left**.

Not too exciting. Let's see if a little detail might perk them up.

I've done several things here to introduce some interest in this wall. What's important as far as perspective is concerned is that the simple addition of details such as the cast shadows under and alongside some of the bricks signals their thickness and helps transform the wall from flat and two-dimensional to solid and three-dimensional. Notice that I chose not to fill in the entire wall with detail. I included only enough to establish solidity and left the rest to the viewer's imagination. Leaving elements of your picture for the viewer to "fill in" unconsciously is one way to get his or her attention.

Siding

Another type of detail that can enhance the feeling of depth is the wood siding found on many of the buildings people like to paint. As in the case of brickwork, you can add interest to the building by noting the type of siding it has and becoming familiar enough with its details to include just enough to get that feeling of solidity we're after.

Here's one type of simple, beveled siding and some uncomplicated cast shadows **(left)**.

I keep coming back to shadows because they are one kind of detail that can be counted on to give some thickness, or depth, to a picture. If the siding is old and weathered, as in my previous sketch, you have some extra opportunity to include details such as nails, cracks, and peeling paint. From a little distance such siding might look like this **(top right)** if you're a neatnik.

But if you loosen up a little and either observe or invent some details, you'll get a drawing like this **(center)**.

As in the case of the bricks, the added detail in the siding helps transform it from something flat and two-dimensional to an object having thickness, or depth. One type of detail that's helpful is the shadow cast by one piece of siding on another. That little strip of shadow tells the viewer that there is one object sticking out beyond the other – and that, in turn, means that there is some thickness, or depth, there.

Notice that even a sunken nailhead has a bit of shadow cast on it by the edge of the board into which it has sunk. The dark cracks and joints between some of the boards are details that help us out by suggesting recesses between the boards. If the boards had no thickness there would be no recesses. And the way the shadow of the tree jumps from one board to the next subtly tells us that those can't be flat boards – there must be thickness, a little ledge, between the bottom of one board and the top of the next. These are all small details, but together they destroy flatness and suggest depth.

There are many kinds of siding. It's up to you to take a close look, learn the personality of the siding you're drawing, and include its essence in your picture. If you want to draw a building convincingly you'll need to pay attention to its clothes just as you would a model's clothes. At **bottom** are some more examples of sidings you may find.

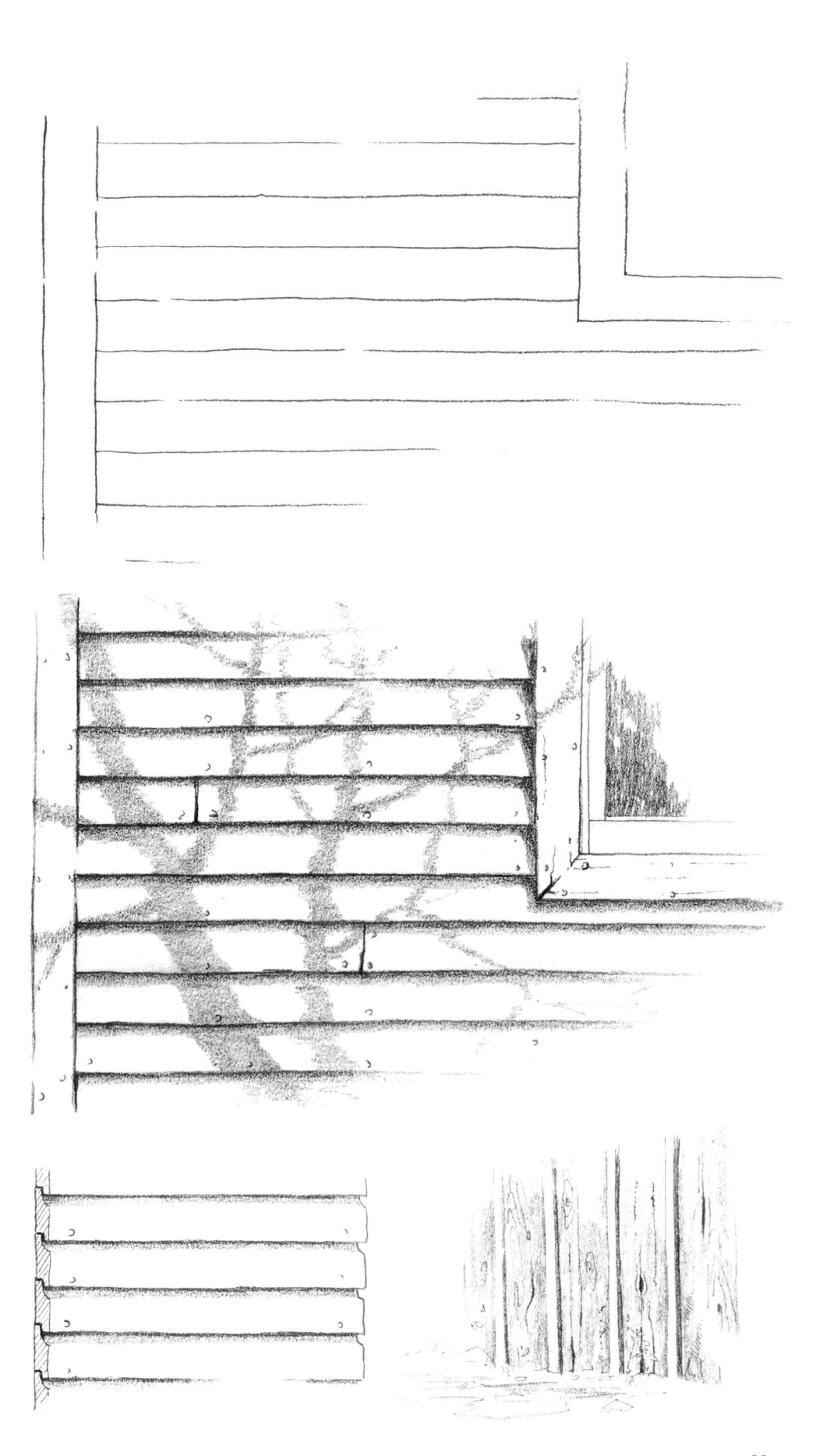

Details

Roofs

The details you observe in buildings vary enormously from one part of the country to another. I'm most familiar with buildings in the East. If you happen to be from Florida or the Southwest you may see lots of stucco and little in the way of wood siding. Wherever you are, you have to get your nose right up close to your subjects and get to know them. As I write this I happen to be in a California motel waiting to give away a daughter in marriage tomorrow. Just out the window I see tile roofs **(below),** unlike those I see in the East.

A closer look shows me how the tiles are overlapped to lead water down and off the roof instead of through it. They look something like the close-up **below left center**.

This overlapping is similar to the way asphalt or cedar or slate shingles shown in the two drawings **bottom**. Notice that the rows of tiles are roughly cylindrical and they go off into the distance the way any cylinder would – that is, the roughly circular ends appear elliptical, and the parallel rows of tiles converge toward a vanishing point.

The point of this discussion is not to make you a house builder. I'm only trying to emphasize that whatever subject you draw, you need to observe its details if you expect to draw it with authority. If I had no idea how tiles were laid, for instance, I might draw them like the sketch at **bottom right**

and end up with the world's leakiest roof. Anyone who knew better would glance at my drawing or painting, snort, and go on to someone else's work, convinced that I didn't know what I was doing.

You don't need to include tons of detail in your picture – in fact, that's often a mistake. What you should pursue is just the right amount of detail (1) to establish perspective and (2) to make your picture work overall. What the "right amount" is, of course, can't be determined by formula. It's a matter of artistic intuition, and what works for one artist will not be right for another. The amount of detail you include will change throughout your artistic life as your style and your taste and your subjects change. One thing is

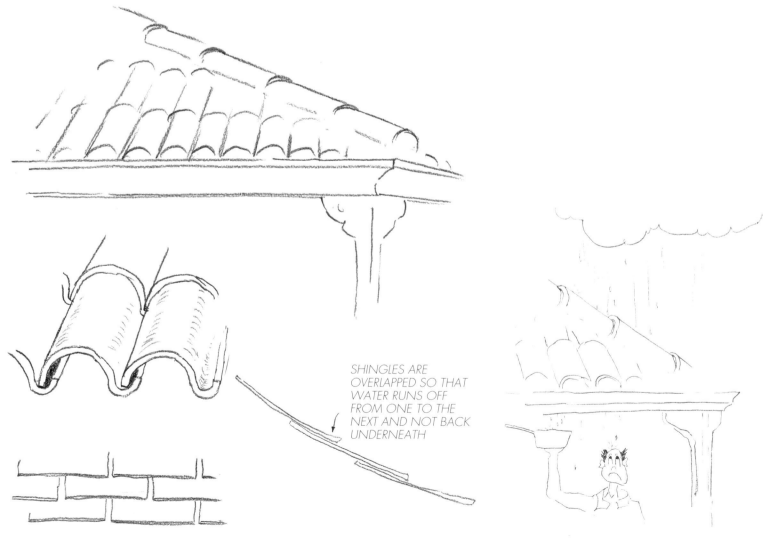

SHINGLES ARE OVERLAPPED SO THAT WATER RUNS OFF FROM ONE TO THE NEXT AND NOT BACK UNDERNEATH

certain, however – the more you understand about the detail of your subject, the more confident you'll become about what to leave out. In a Dale Carnegie course on making speeches, the student is told to know forty times as much about his subject as he intends to include in a given speech. Having all that understanding stored away gives him the confidence to choose wisely the few nuggets he'll present to his audience.

Let's return for a moment to the subject of these workbooks. Perspective: techniques for attaining an illusion of depth. The use of detail is one of those techniques, but it in turn utilizes some of the others, such as overlap, modeling, size variation, and linear perspective. Effective use of perspective nearly always involves a marriage of a number of techniques, rather than a solo performance.

Exercise 1/**Details**

In each pair of sketches, "finish" the light one in a manner similar to mine to get a feel for the impact of detail on perspective. Don't be put off by the fact that you're "only" copying – the idea is to see how detail can nudge a flat sketch away from its flatness and give it a sense of depth. In each case, be sure to select a light source position before you start. Your light source need not be the same as mine. If mine is on the right, you might place yours on the left.

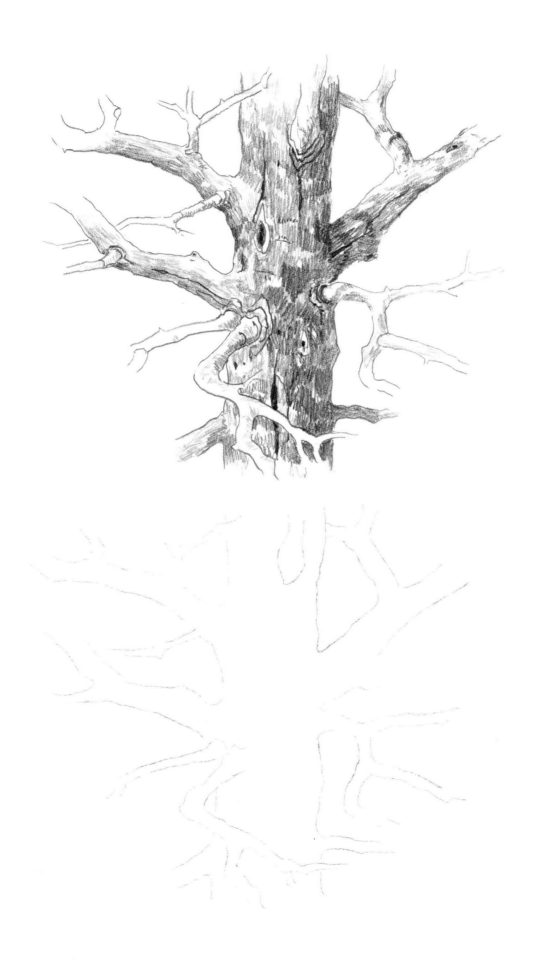

Sketch by Shirley Porter.

More Carpentry

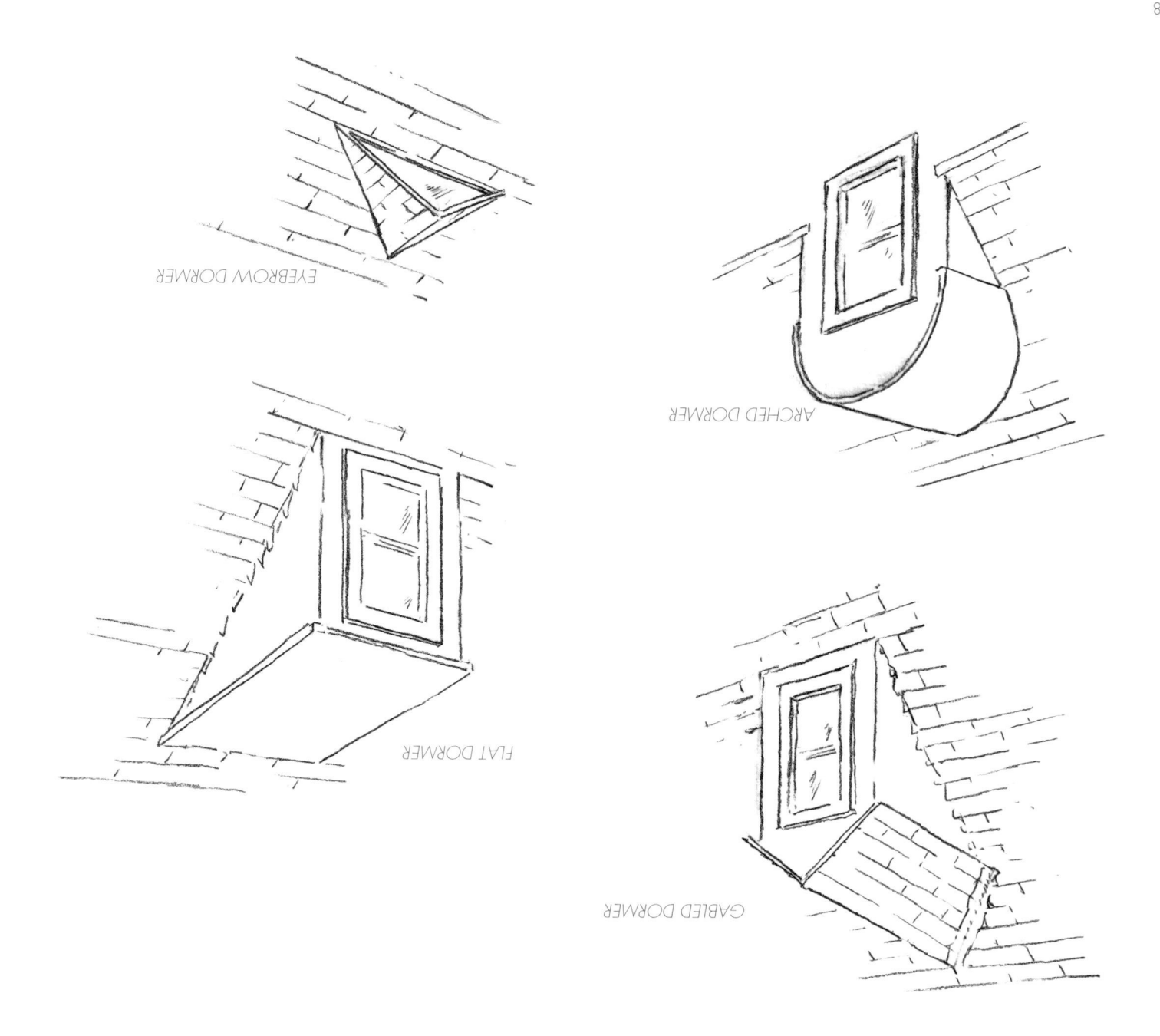

EYEBROW DORMER

ARCHED DORMER

FLAT DORMER

GABLED DORMER

So far in these workbooks we've drawn lots of boxy houses and barns, but we haven't added many of the features that give these buildings their unique personalities; we've kept them simple in order not to obscure their basic lines. The differences among buildings are endless and we can't hope to cover them all, but we can study a few examples that will serve as a foundation for drawing building details you're likely to encounter. What we'll be concerned with here are parts of buildings where linear perspective is important.

Dormers

First let's tackle a dormer. That's a structure stuck onto a sloping roof and containing a window. They come in lots of shapes and sizes, including the ones shown **below.**

What might get confusing is figuring out the funny angles where the dormer intersects the house's roof. Happily, you don't have to. Start with things you're familiar with – rectangular boxes whose lines recede to vanishing points – and the funny angles will take care of themselves.

Think of a dormer as a little house set at right angles to a bigger house **(below)**.

First you have to decide where to place the dormer on the roof. A single dormer will often be centered. If there are two or more, you'll have to decide just where the dormers are to be located in your drawing either by using your powers of artistic observation (that is, guessing) or by doing some more elaborate construction. If you're going to be fussy about all this, you'll find a section later on in this workbook that will help you with the matter of accuracy.

Next draw the major lines of the dormer. Remember that this little

dormer, like a doghouse sticking out of the main roof, obeys all the "rules" of linear perspective. Its horizontal lines will recede to the same vanishing points as those of the main house. If this were a weird dormer set at an odd angle to the house, this would not be so, but that's a rarity.

As shown at **bottom**, the dormer's roofline *(b)* should slope toward the left and hit VPL, the same vanishing point hit by the left-slanting lines of the main house. The bottom edge of the dormer *(c)* will slant toward VPR.

The steps for drawing the front shape of the dormer are the same as those we followed while drawing houses in Volume 1, Part 2. But how

do we determine the lines showing the intersection of the dormer and the main roof? It's easy if you realize that the lower edge of the dormer's little roof, line *k*, goes to VPL and that line *m*, where the side of the dormer meets the main roof, is parallel to the front edge of the main roof. Line *n* shows where the dormer's roof intersects the houses's roof. Where this line falls depends on the view you choose from which to do your drawing. Draw the other lines first and let them dictate where this one ends up.

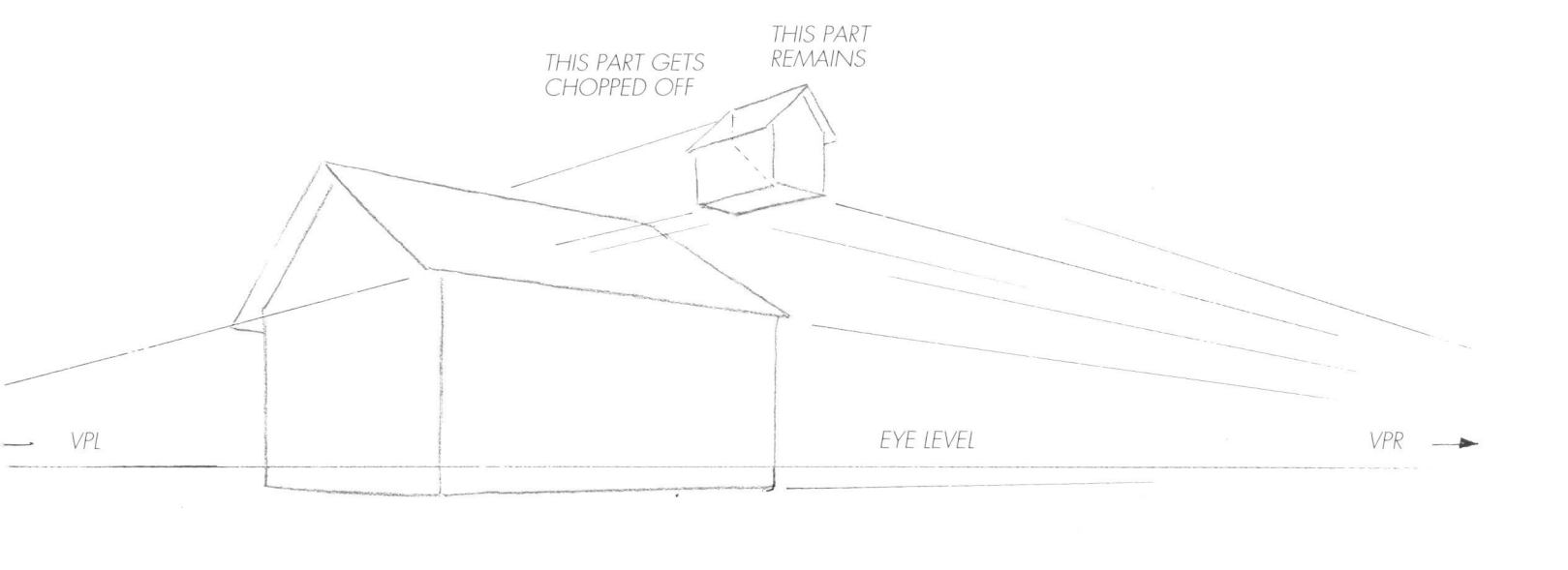

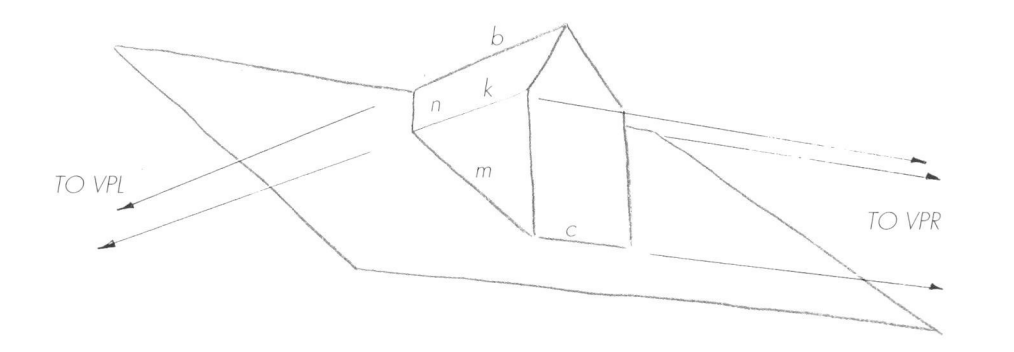

On **page 61** is one side of a slanted roof. The problem is to build two dormers ("gabled" dormers, as illustrated in the text). I've shown where the peak of each dormer's roof is to meet the peak of the main roof of the house. I've also shown the slant of the top of the roof of the nearer dormer (No. 1). Do dormer No. 1 first, since the second dormer will be partly hidden by the near one. The steps would be as follows:

Step 1: Draw line c to indicate where the bottom edges of the dormers are to meet the roof.

Step 2: Draw line a parallel to the front edge of the roof. Draw vertical line d through the intersection of a and c. Line d divides the front face of the dormer in two (in perspective).

Step 3: Draw lines e, f, and g, defining the rectangular part of the face of the dormer. The heights of e and f are up to you. Line g goes to VPL. Draw h and j to get the triangular portion of the face of the dormer.

Step 4: Draw line k toward VPR; draw line m parallel to the front edge of the roof. Finally draw line n. Then add dormer roof overhang, window, and other details.
 Draw dormer No. 2 the same way. Depending on the position from which these dormers are being viewed, and also on how wide you chose to make dormer No. 1 and how far out from the main roof you decided to build it, portions of dormer No. 2 may be hidden behind No. 1. Although dormer No. 2, because of perspective, will appear smaller than No. 1, their shapes will be the same (again, allowing for perspective distortions).

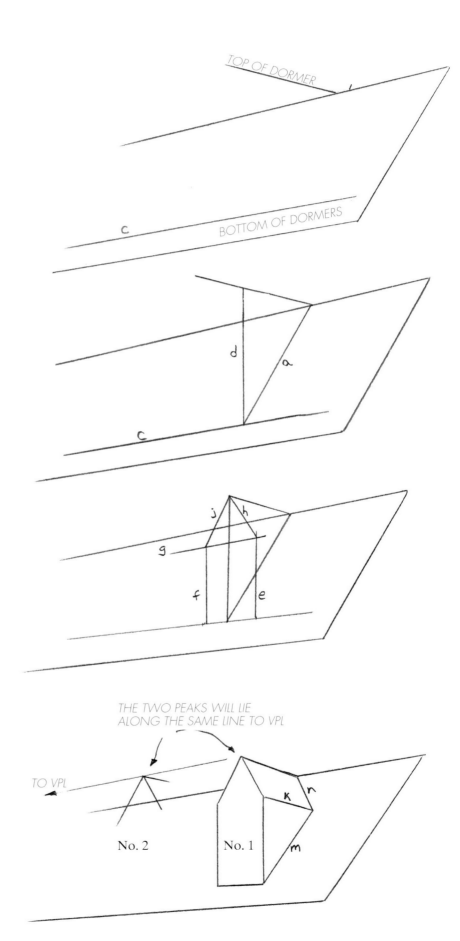

TOP OF DORMER

BOTTOM OF DORMERS

THE TWO PEAKS WILL LIE ALONG THE SAME LINE TO VPL

TO VPL

No. 2 No. 1

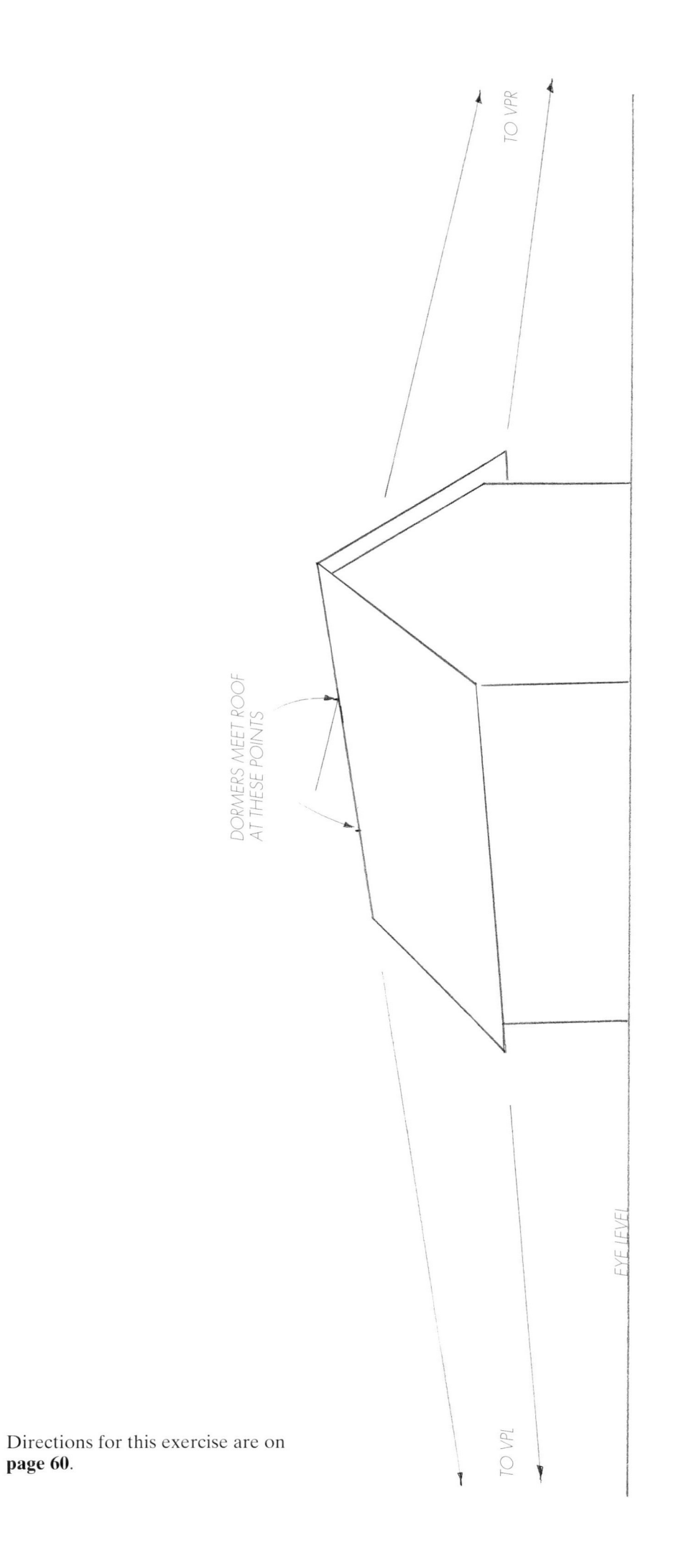

TO VPR

TO VPL

EYE LEVEL

DORMERS MEET ROOF
AT THESE POINTS

Directions for this exercise are on
page 60.

More Carpentry

Windows and Doors

Another bit of carpentry that often eludes an artist who doesn't look closely at the subject is the construction of windows and doors. If you're drawing from a great enough distance, it doesn't much matter, but in close-up views your understanding of these building details can be important.

For example, consider the difference between the two windows **below**. The left-hand drawing shows some understanding of how a certain type of window is built. It's a so-called "double-hung" window; the upper and lower halves slide up and down independently. In the left-hand sketch, the lower window is shown recessed – that is, the upper window overlaps the lower. They're always that way, like shingles on a roof, so the rainwater will not get inside the house. The sketch at the right has little depth; it does nothing to convince us it's real.

There's something else to watch out for in drawing such things as windows. Although this has little to do with perspective, I think it rates a mention here. Avoid unreasonable placement of windows in a building, such as the goofs at **bottom**.

In the first, we have a window looking out from a chimney. In the second, the upper two windows are too low. In the third example, the upper windows are too high. You can avoid discrepancies like the last two if you mentally place people in your building and see how they fit.

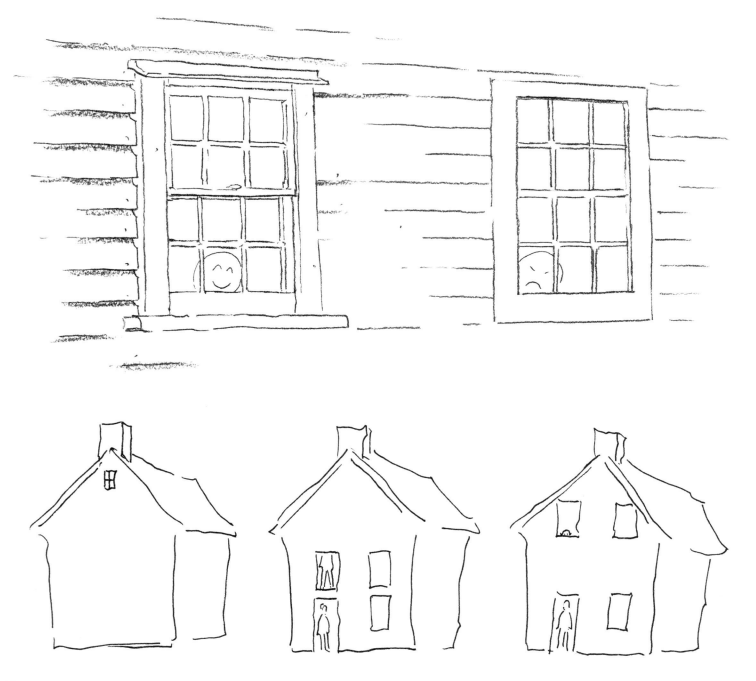

Trim

There are a trillion different kinds of trim you'll encounter on various buildings. You can use trim not only to decorate your painting but to enhance perspective as well. It's easy to be thrown off in your drawing when copying such shapes as those **below** and trying to get them all the same shape!

You may forget to draw the bracket that's farther away smaller than the one closer to you, for example.

You'll find that if you first draw one of the decorative brackets to your satisfaction and then run some light perspective guidelines, drawing the remaining brackets will be much easier than trying to draw each bracket independent of the others **(below center)**.

Another example of "trim" is what often appears at the edge of a barn or shed roof, where the roof rafters are simply allowed to show rather than be concealed under some nailed-on boards **(bottom)**.

Such construction offers the artist a chance to include a bit of interesting detail. Although it's doubtful that barns were built this way for reasons other than economy, the same idea is carried forth in many houses today to provide a rustic look.

TO VPR

GUIDELINES HELP
KEEP SHAPES
ACCURATE

In both parts of this exercise, it would be a good idea to fasten your worksheet down and tape enough extra paper alongside the worksheet to allow you to locate and keep track of vanishing points.

Many older buildings have decorative cornice brackets. Using the bracket I've drawn as a starter in (a), draw light guidelines to the appropriate VP and use them to help you to draw two more brackets at the positions indicated. Remember that the heights of the brackets will diminish as they recede; their thicknesses, too, will diminish.

Draw a second spindle support in (b). I've drawn a line to indicate the location of the nearest edge of the spindle you are to draw.

(a)

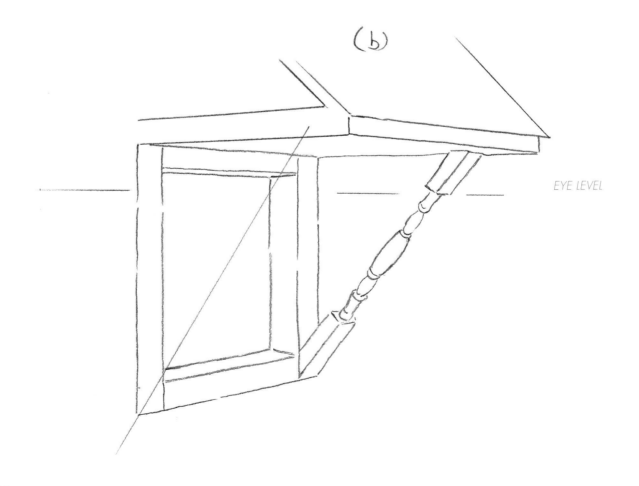

(b)

EYE LEVEL

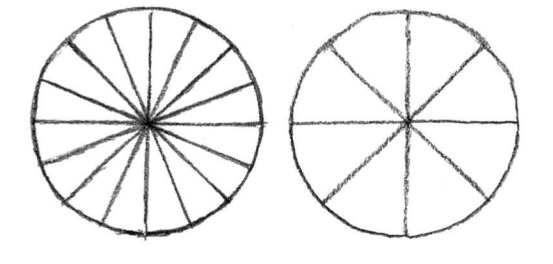

Frequently artists need to place lines on a curved surface to represent evenly spaced spokes in a wheel, flutes or grooves in a column, windows in a rounded tower, and the like. I'll demonstrate an easy way to do this, using spokes, as detailed in the lesson beginning at right. This method is called projection.

Suppose this wheel is thrown into perspective, and we no longer have a circle but an ellipse. We can quickly find four of the spokes by drawing the two axes of the ellipse, but the remaining spokes are not quite so obvious. All we know intuitively is that the farther we get toward the skinny ends of the ellipse, the closer together the

Spokes

If a circular object such as a wheel is viewed straight on, with no perspective involved, it's easy enough to draw its spokes. The wheel can simply be divided and subdivided as many times as you wish to get the appropriate number of spokes, **right**.

spokes will appear. At the right is an approximate way of finding out how the spaces between the spokes vary. First, draw a circle above the ellipse with a diameter the same as the long

dimension of the ellipse **(below center)**.

Next divide the circle, like a pie, into the number of equal slices you wish. Let's go with eight.

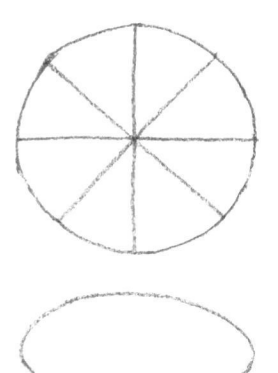

Then draw vertical lines down from where the spokes intersect the circle, to the ellipse.

Now draw your spokes from the center of the ellipse to each point where the vertical lines hit the ellipse. The resulting wheel spokes are a

reasonable approximation of what happens in perspective.

To get it more nearly right, move the center of the ellipse back a little to come closer to perspective center before you draw your spokes.

As you can see, projection means

drawing guidelines from one view of an object to a second view of that object to determine where critical parts of the object will appear in the second view. We'll use projection further in the examples that follow.

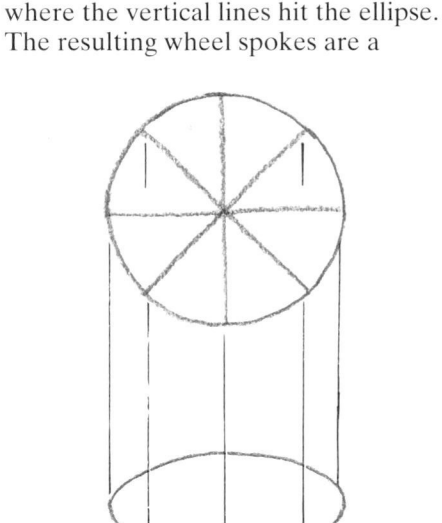

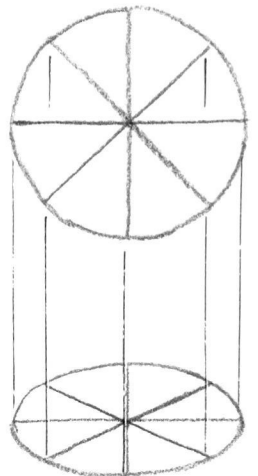

FOR MORE ACCURACY I MOVED THE "CENTER" BACK A LITTLE TO PLACE IT AT PERSPECTIVE CENTER

Using the projection method, draw spokes in perspective in the ellipses corresponding to each circle. In the fourth example, show the width of each spoke in perspective.

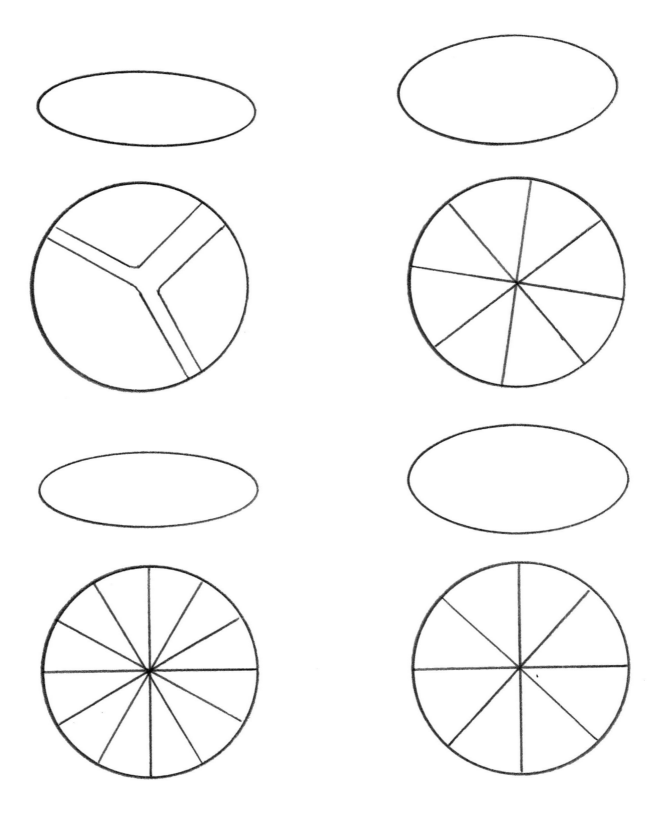

Flutes

We can extend our handling of spokes to other objects. Imagine you are drawing a fluted column. Let's say the end of the column looks something like this, with sixteen flutes, or grooves.

If we're viewing the column from its side, all that's necessary is to draw sixteen "spokes" in a circle above the column and draw vertical lines downward to show the placement of the flutes.

You can get as fancy as you want. If you'd like to project onto the column not only the locations of the flutes, but their widths, as well, then show the "spokes" in your circle as having appropriate thickness and project down twice as many vertical lines **(bottom far right)**.

Notice that the widths of the flutes gradually decrease in perspective as they get nearer the edges of the column. Notice, too, that you automatically get the proper widths of the ribs separating the flutes. In fact, the spokes in your circle can represent either the flutes or the ribs, whichever pleases you. One person's rib is another person's flute.

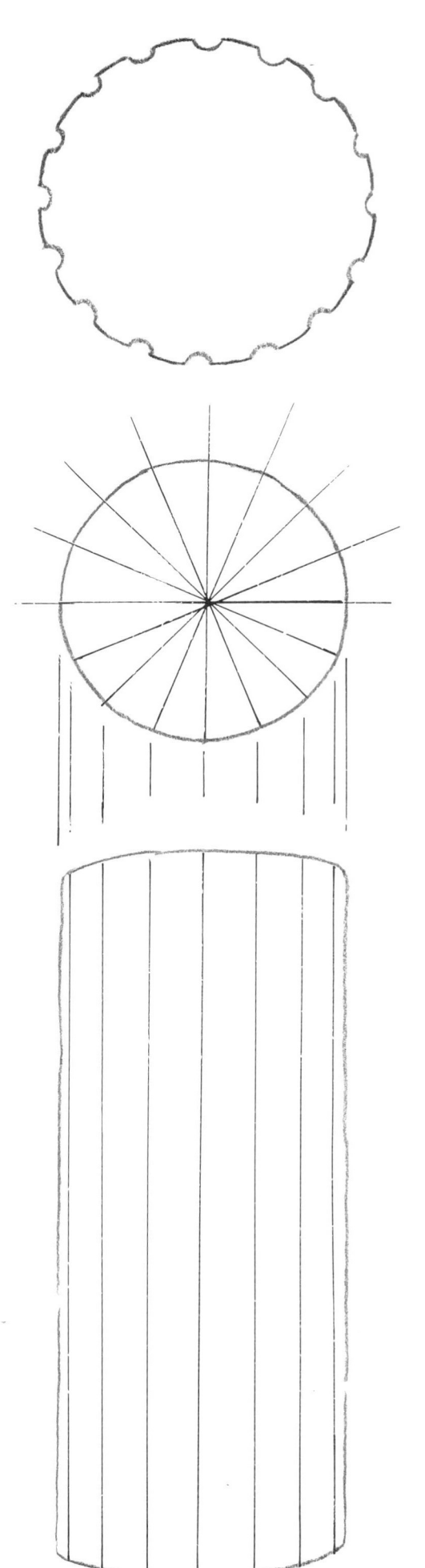

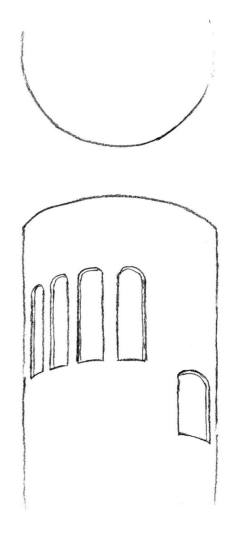

A Rounded Tower

The same sort of construction helps us to draw a rounded tower with windows. Start with an outline of your tower and a circle above it (or below it, whichever seems more comfortable – **left**). The diameter of the circle is the thickness of the tower.

Mark off pie slices on the circle to represent the widths of the windows. There's no need for the windows to be the same widths as the spaces between them, of course. For that matter, the windows need not be the same size, nor evenly spaced, nor even on the same level. Let's say we have five windows, spaced and in the sizes shown at **center**. Drop vertical construction lines.

Now draw in the windows at an appropriate height. If we assume they are arched windows with flat sills, then in perspective they might look something like the drawing **above right**.

In this sketch you have a building's dome and a circular base. Between the dome and the base are to be thirteen columns. Using the projection method, place the thirteen columns. Start as usual by dividing a circle into thirteen equal slices and projecting down to the ellipses. You can get the thickness of the columns either by starting with thick spokes in your circle (the more accurate way), or add the appropriate thicknesses after you've placed the columns.

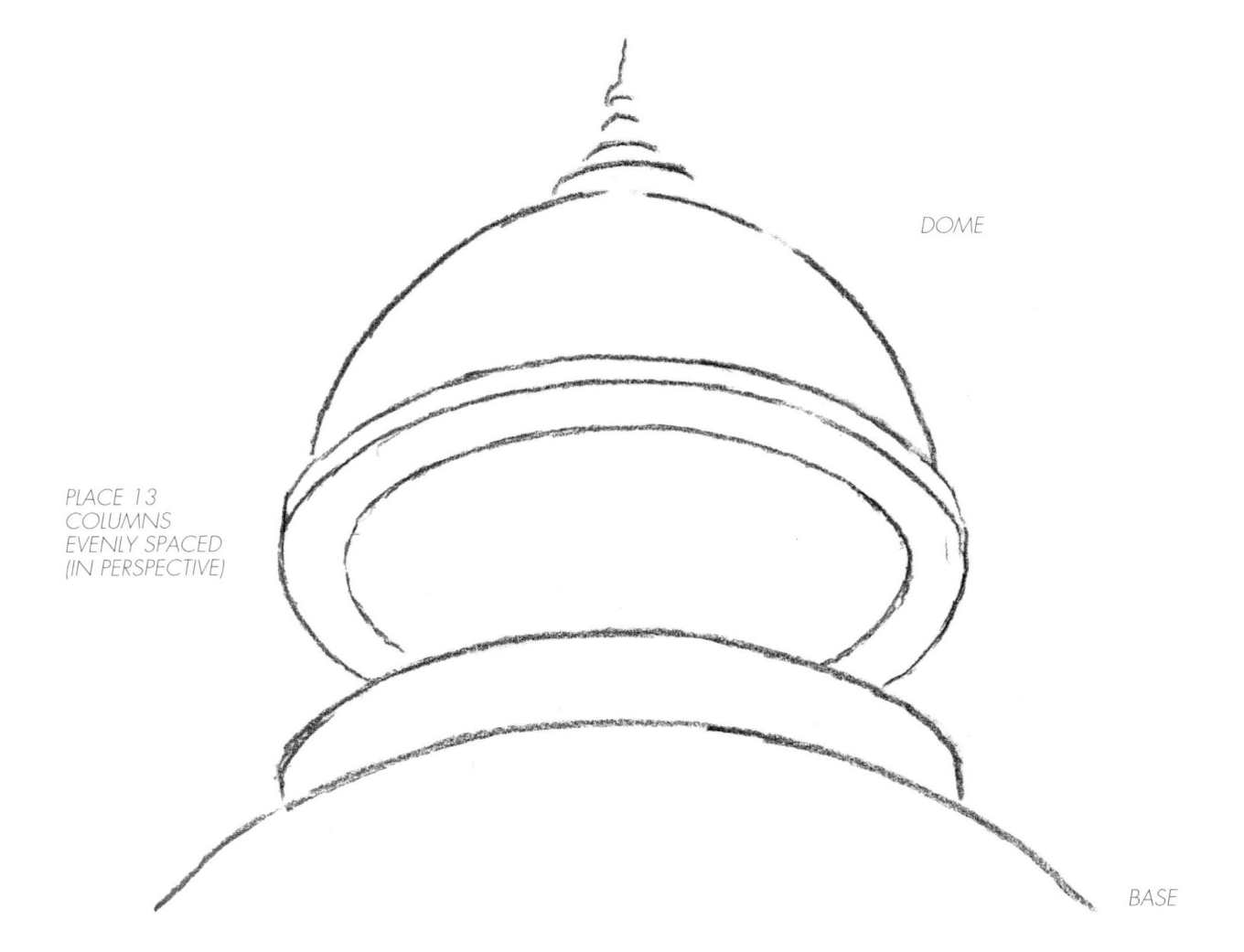

DOME

*PLACE 13
COLUMNS
EVENLY SPACED
(IN PERSPECTIVE)*

BASE

Some Extrapolations

The kind of construction we discussed in the last section will help you out in drawing lots of rounded subjects, including such grand things as monuments or capitol domes. But some subjects are not rounded and yet seem to pose similar drawing problems.

Beginning at the right, we'll look at how simple it can be to draw more complex shapes.

Nuts!

Let's think small for a moment. How about drawing something like a nut or a bolt? You can probably find a loose nut around the house. It might look a little complicated to draw, but we can draw it using the spokes method. The nut I'm using as a model is hexagonal.

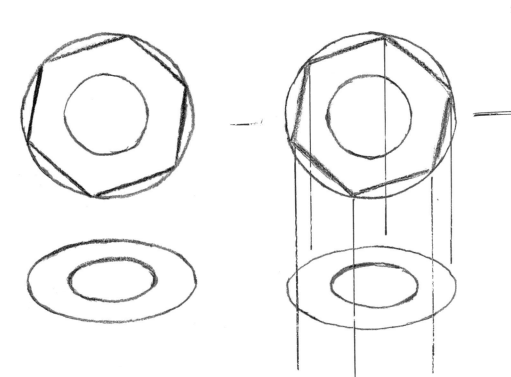

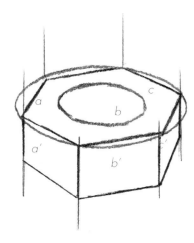

First, draw a circle whose diameter represents the nut at its widest dimension and draw the nut inside the circle in whatever position you choose. Then draw an ellipse under the circle. Make the ellipse as fat or as flat as you wish to get the amount of perspective you wish. Draw a smaller ellipse with the same perspective center, for the hole in the nut.

Drop vertical construction lines. Where they hit the ellipse, they define the points or edges of the nut.

Now connect the points and then extend the vertical edges of the nut downwards as far as you judge necessary to show the nut's thickness.

Lightly draw line *a'* parallel to *a*; *b'* parallel to *b*; and *c'* parallel to *c*. That'll be almost right, but not quite. Remember that we're seeing this object in perspective, so pairs of lines, such as *a'* and *a*, that we know are parallel in the actual object are not parallel when the object is seen in perspective. Those pairs of lines will all converge to vanishing points. All three vanishing points will be on your eye level. As in so many cases, you don't need to draw the converging lines, but simply slant *a'*, *b'*, and *c'* slightly more sharply upward than their counterparts, *a*, *b* and *c*.

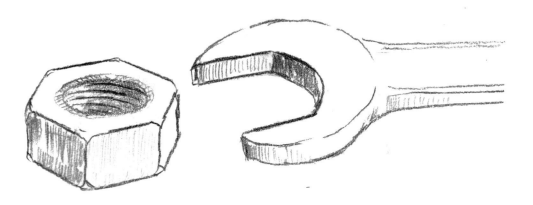

Finally, go ahead and have fun putting the finishing touches on your drawing.

Minaret

An example similar to that of the nut is this minaret **below**. The basic structure is octagonal. No matter how many sides an object has, if its cross-section can be fit into a circle, the spokes and flutes projection method will help you to draw it. The annotated drawings

that follow will describe the drawing process. It may look complicated at first, but if you'll follow it step by step, you'll see that even complicated structures can be almost as easy as the nut we just drew.

For a little variety I've turned the structure at a different angle in the construction drawings. Whatever you

do, don't get too wrapped up in the construction. Some of the steps that I show in this and other examples are only there to get your mental juices flowing in the right direction. Usually you can get by with just enough "construction" to place critical edges and then trust your drawing instincts from there.

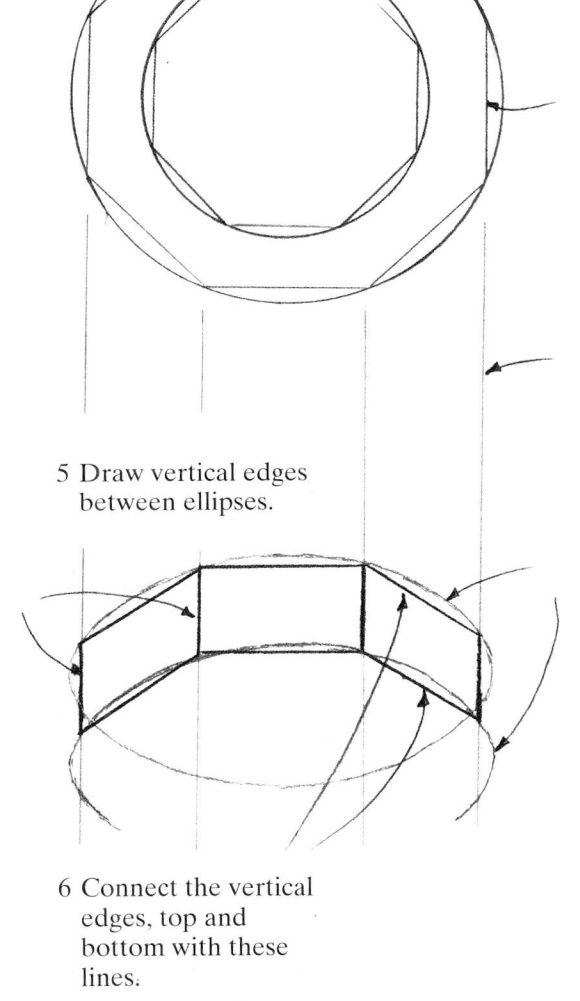

1 Draw circles with diameters equal to the widths of the sections – I've shown just two of the circles here.

2 Draw eight-sided shapes inside the circles.

3 Project lines downward to be used in locating edges.

4 Sketch ellipses showing amount of perspective you want. Make them as flat or circular as you choose.

5 Draw vertical edges between ellipses.

6 Connect the vertical edges, top and bottom with these lines.

7 Take a rest.

Some Extrapolations

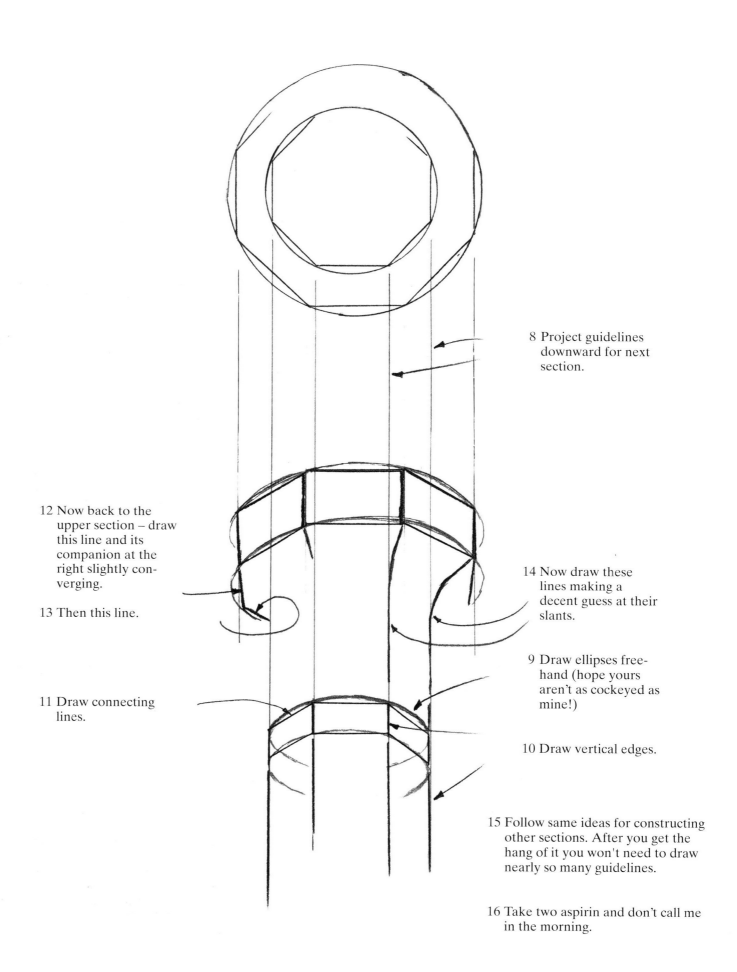

8 Project guidelines downward for next section.

12 Now back to the upper section – draw this line and its companion at the right slightly converging.

13 Then this line.

14 Now draw these lines making a decent guess at their slants.

9 Draw ellipses free-hand (hope yours aren't as cockeyed as mine!)

11 Draw connecting lines.

10 Draw vertical edges.

15 Follow same ideas for constructing other sections. After you get the hang of it you won't need to draw nearly so many guidelines.

16 Take two aspirin and don't call me in the morning.

Beyond Eyeballing

Sometimes we get involved in subjects that demand more accuracy than is possible with casual eyeballing or thumb-and-pencil measurement. Here is a method of determining how evenly spaced objects of equal size diminish in size and spacing as they recede.

Upright Objects

Suppose you're drawing a neat row of utility poles stretching across a flat piece of land. The poles are all the same size and the spaces between them are all equal. How do you proceed?

First establish the eye level, and then draw the first pole. Draw guidelines from the top and bottom of the pole to a vanishing point on the eye level. Then draw a second pole between the guidelines, guessing at about where it should be placed.

Cross diagonals to find the perspective center of the four-sided shape you've formed and draw a line from that point to the vanishing point.

Now draw a diagonal line from the top of the first pole through the "middle" of the second pole. It will hit the lower guideline at the foot of the third pole. Draw the third pole.

Draw a diagonal from the top of the second pole through the "middle" of the third pole. It will hit the bottom construction line at the foot of pole 4 … and, as Walter Cronkite used to say, that's the way it is. You can go all the way to the horizon in this manner and have a perfectly orderly set of poles when you're done.

Beyond Eyeballing

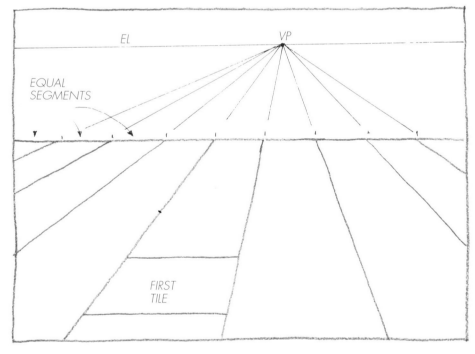

A Tile Floor

Perhaps more useful would be an example such as a tile floor. Sometimes we include them in interior paintings or still lifes, and if they're not right they'll ruin the painting by making the floor seem to tilt too much or not enough.

Suppose you're drawing a tile floor from a vantage point something like this. You've chosen your viewing position a little right of center (but it could have been at center or left of center).

We'll first draw this floor in one-point linear perspective. The vanishing point will be directly ahead of you – on the eye level, of course.

The reason for choosing one-point is this: when you are so close to a subject (you're standing right on the tile floor, let's say), a second vanishing point would be so far to your right or left that the lines converging toward that VP would have negligible slant. In other words, one-point perspective may be considered two-point perspective with one of the vanishing points out around Mars. For practical purposes, the lines in the tiles running right to left across the scene are parallel to the picture plane. If the floor were large enough – that is, if it stretched far enough away from the viewer – in that case there might be some discernible two-point perspective. An example a little later will illustrate this.

As you can see in the sketch **left**, I've drawn in the lines representing the rows of tiles (they could be floorboards at this point). How do you make them fan out properly? The easiest way, and accurate enough, is to mark off equal widths along the edge where the floor meets the far wall. Then draw lines through those points and the VP.

Next, pick a pair of horizontal lines near to you and sketch them in to define your first tile. These are like the first two poles in the earlier example; once you establish them, everything else becomes pretty mechanical. You may need to experiment a little to get these lines feeling right.

Draw right on this sketch and follow along with me through the rest of the steps.

Locate the perspective midpoint of the tile by crossing its diagonals, and draw a construction line through it to the VP.

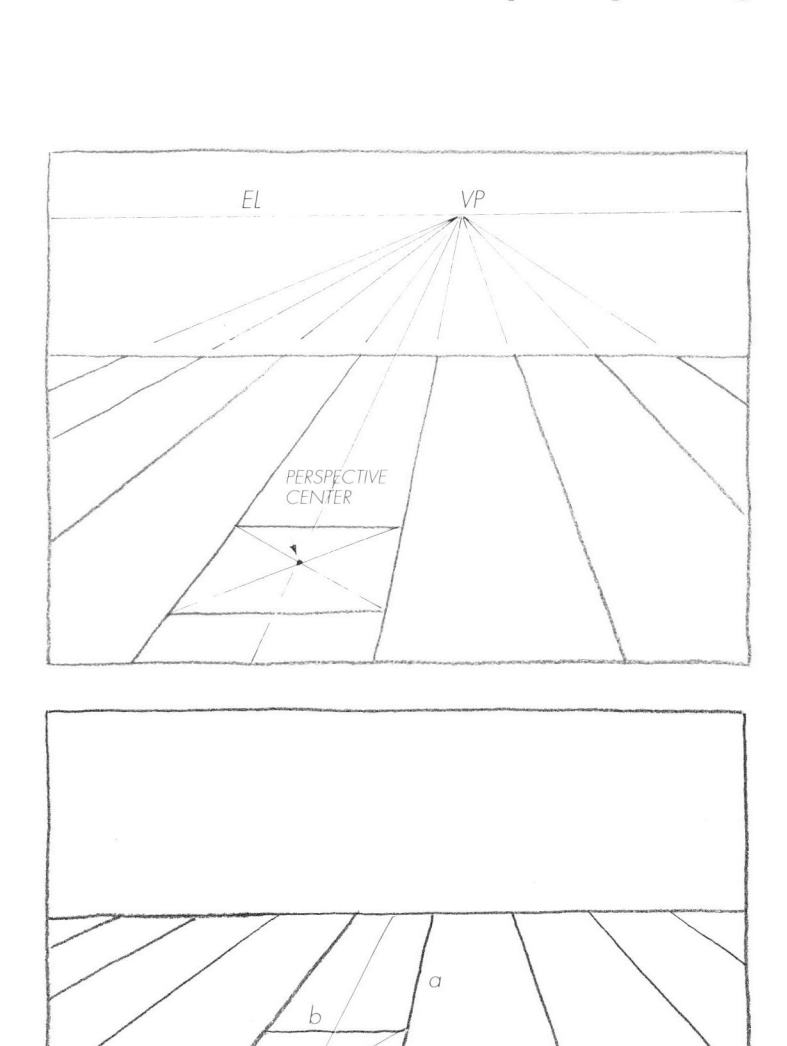

Draw a line from one end of the near tile edge through the "midpoint" of the far tile edge. Where that line hits line *a*, draw horizontal line *b*.

Continue this process until you hit the far wall. If the last tile doesn't come out exactly where the far wall begins, move the wall a little. Nobody will tell.

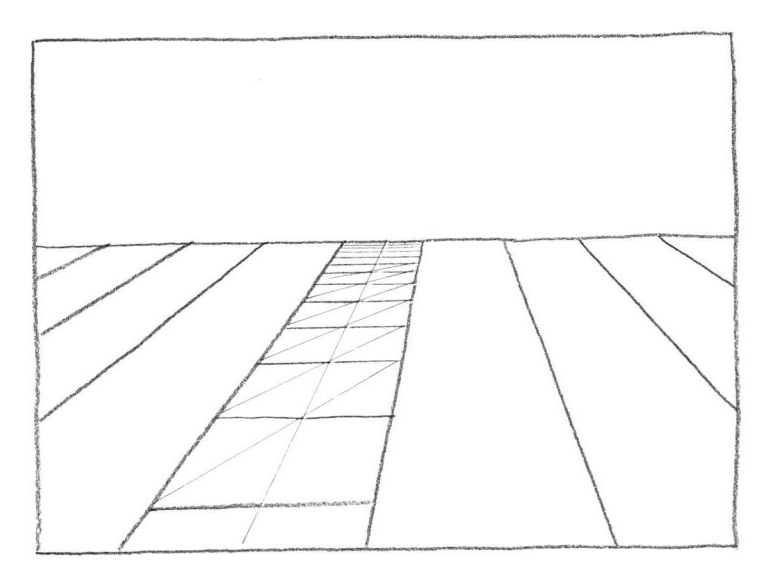

Beyond Eyeballing

Complete the floor. You can extend all the horizontal lines to the left and right, as shown here.

Or you can extend those lines only to alternating rows of tiles (if your floor is one with staggered joints) and draw another set of horizontal lines for the in-between rows of tiles.

Notice that line *m* isn't halfway between *p* and *q* – at least, not as the crow flies. It's halfway between *p* and *q* in perspective. To find instantly where that perspective midpoint is, cross the diagonals of the perspective square tile.

I mentioned earlier that in some instances you might want to use two-point perspective. You do everything the same except that you must draw the first two tile edges as slanting toward a second vanishing point (far to the left in my example, **left**), rather than draw them as horizontal lines. You'll see that if you give much slant to these lines your floor will feel as if it's tilted and running off the lower corner of your picture.

VPR

VPL

Here's a straight country road with utility poles on one side and fence posts on the other. The road is made of equal concrete sections. Draw the remaining posts, poles and sections. The concrete sections can be drawn using the method in the text for tile floors. I've given you a second post to start them off; decide for yourself how much distance you want between poles and how long the concrete sections are to be. Note that I've indicated the two vanishing points on the horizon.

Placing People Properly

You might think people could be treated the same as any other objects in a drawing, and in some ways that's true. But because we observe people all the time we have a built-in, unconscious understanding of how they should look, and any liberties we take in drawing them in a scene are almost certain to be noticed. We can fudge the size or shape or position of a barn and get away with it, but if we take too many similar liberties with people, the results are usually all too obvious. Here are some general ideas about including people in a scene in proper perspective.

Scale

It's important to place people so that they seem in scale with their surroundings. The guy at **top right** looks as though he's about to embrace the utility pole.

But actually he's only waiting for the damsel to rush into his arms **(bottom right)**.

There are two things wrong in this picture. First, the male figure is placed awkwardly next to the pole; second, either he's pretty tall or the pole is awfully short – there's something wrong with the scale, or proportions, between the two objects.

The first problem is easily resolved by leaving more space between the man and the pole. However, you might argue with my second point, saying that the pole is in the distance and that's why it looks so short. But if the pole were far enough in the distance to make its *height* plausible, it would be too *thick*; at that distance it should look slimmer. There's no way it could look almost as thick as a man – even a skinny man wasted away by love!

The simplest way to avoid placing figures awkwardly is to compare their heights with other objects that are as

far back in the picture as they. Start with the knowledge that most people are 1.50 to 1.80 meters tall. Then observe how high some common things are: many rooms have ceilings over two meters high; a common doorway height is about two meters; a kitchen counter is about one meter; and so on. Get the height of one object the way you want it and fix the heights of all

other objects (including people) relative to the object you started with.

If you have a mix of people, say adults and children, you have to rely a lot on clues other than height to signal what's going on. If, for example, the dress and the proportions of one figure clearly say "child," then that figure will not seem awkwardly placed next to a taller figure who clearly is an adult.

Eye Level

Whether you're painting barns or people or both, the eye level you establish for your picture is critical. Once you've established the eye level from which your scene is to be painted, all the objects (including people) in your picture must relate to that eye level. Let's consider a couple of examples of scenes with people.

First, suppose your scene is some flat area, such as a beach or a city square or practically anywhere in Indiana. Assume you're painting the scene standing at your easel. If you're an "average" person, your eyes are roughly 1.5 meters from the ground, so the eye level in your painting is 1.5 meters from the ground. So are the eye levels of all those average people in your painting. In other words, everybody in the scene who is of average height will have his eyes on the same level, 1.5 meters above the ground, as shown **top**.

What about the little twerp at the left? This figure is clearly a child, not just some adult off in the distance. How do we know that? Because, given a flat area like this, all standing adults have the same eye level. There's no way this little guy can be a regular adult and not have his eye level at the same height as everyone else's eye level.

A receding row of people along a flat area will diligently obey the "rules" of linear perspective, the same as pickets in a fence or poles along a road. That is, if you draw guidelines from the top and bottom of any of the figures in the sketch to any vanishing point on the eye level, you can fit as many other similar figures as you wish in between those two guidelines and they'll look right.

I've drawn in one pair of guidelines **(bottom)** – you draw in some others. Then sketch some people (1.5 meters-eye-level people) anywhere you wish between those pairs of lines and they'll look right. Try it. Don't forget to make the more distant figures skinnier and, of course, less detailed than nearer ones, in keeping with perspective techniques we've already discussed.

Suppose you wanted to add more

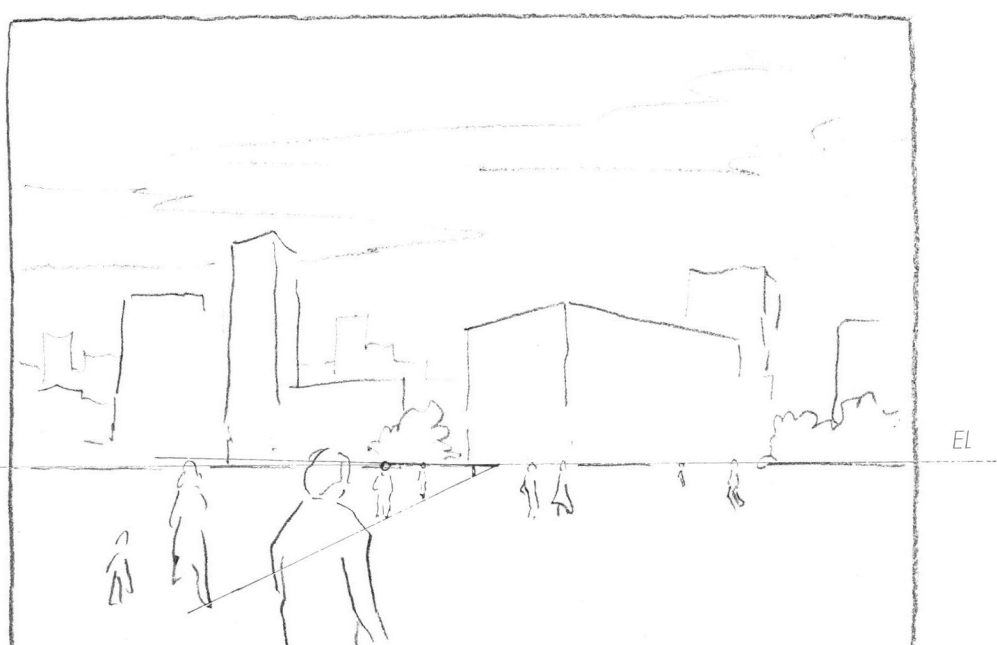

EL

children to this sketch. Remember that they are *below* your eye level. If a child is as far back in the scene as some adult, what the two will have in common is not their eye levels, but rather their feet level. If an adult and child are side by side, their *feet* will be on the same level (unless one of them is floating). So start with the feet and draw the child from the feet up.

Placing People Properly

Adjust children's heights relative to the heights of those around them. Once you get one child where you want him, you can add others in perspective, farther back or nearer, by drawing a pair of guidelines from the top and bottom of the established child to a vanishing point, just as we did with the adults. Then fit as many children as you want between those guidelines and you'll have a bunch of same-height children in proper perspective. If you want to practice a little more on this sketch, draw guidelines from the top and bottom of the child at the left to a vanishing point on the eye level, and fit some children between those guidelines.

Suppose the scene you're depicting is not flat. There may be some people in the picture whose eyes are at the picture's eye level, some above, and some below, as in this sketch.

What you must rely on here, other than careful observation, are techniques such as these:

- Size variation: Show a plausible size difference between near and distant people; measure their relative heights with thumb and pencil.
- Detail: Show less detail in figures farther away. Compare the figures on the hill to the one carrying the basket.
- Overlap: A couple of the figures have their legs "cut off" because the hill overlaps them. This visually pushes the figures back into the distance behind the hill.
- Scale: Establish scale by placing figures near objects whose sizes are generally understood by most viewers, such as the beach umbrella at the right in the sketch.
- Visual clues: Give the viewer hints about what's going on. For example, if a figure is meant to be below eye level, give some clues to prove it. In the sketch the figure carrying the basket and umbrella is below eye level (the ocean horizon off in the distance), and I have tried to underscore that fact not only by where I placed him, but by simple clues: you're looking slightly *down* into the basket he's holding; you're looking *down* on his hat, not seeing up beneath it.

In several sections of these workbooks we have discussed the importance of shadows in enhancing the feeling of depth in a picture. In Volume 1, Part 1, for example, we discussed the type of shadow that hints at depth by helping to describe the thickness of an object. Remember the apple illustration? I first presented an apple as a flat shape that had no apparent thickness or depth. But as soon as I added shadow to the side of the apple away from the light source it became a three-dimensional object, no longer flat. That type of shadow, the shadow occurring on the side(s) of an object opposite the light source, is generally called *modeling*.

Later I introduced another type of shadow called *cast shadow*. A cast shadow is an area on any surface that is darker than the surrounding area because light is blocked and prevented from reaching it. Again going back to the apple in Volume 1, Part 1, both types of shadow are present – the shadow on the half of the apple away from the light source (modeling), and the shadow on the table surface caused by the apple blocking the light (cast shadow).

We know intuitively that the cast shadow we see could not exist if there were not an object of some thickness blocking the light. So both types of shadow aid in promoting the feeling of depth in an indirect but vital way: by suggesting the thickness, or third dimension, of an object.

Another way in which shadows, especially cast shadows, add dimension to a picture is by telling the viewer about shapes and thicknesses he or she might otherwise not see. Earlier in this workbook, for example, I mentioned the importance of such details as the thickness of bricks or the overlapping of house siding.

It's often because of cast shadows that the viewer is even aware of such details. Cast shadows help define shapes because wherever they fall they must follow the contours of the areas they are falling upon.

Because shadows can be so helpful in getting depth in a picture, it's important to understand what makes them tick. The following sections should shed some light on shadows.

Shadows Are Not Reflections

There is often confusion between shadows and reflections. We'll get to reflections in the next section, but for now remember: a *shadow* is an area receiving less light than other areas because something is blocking the light; a *reflection* is an image you see caused by light from an object bouncing from some surface and reaching your eye.

In the **top** sketch, the light source (sun) is at the left. Its rays get to everything except the area blocked by the pole. That area is the pole's shadow. The reflection seen in the water is caused by light traveling from the pole, hitting the mirror-like surface of the water, and bouncing up to be seen by the eyes of the observer.

If we shift the position of the light source (the sun), say by moving it back some behind the pole, the position of the shadow changes but the reflection remains the same **(bottom)**.

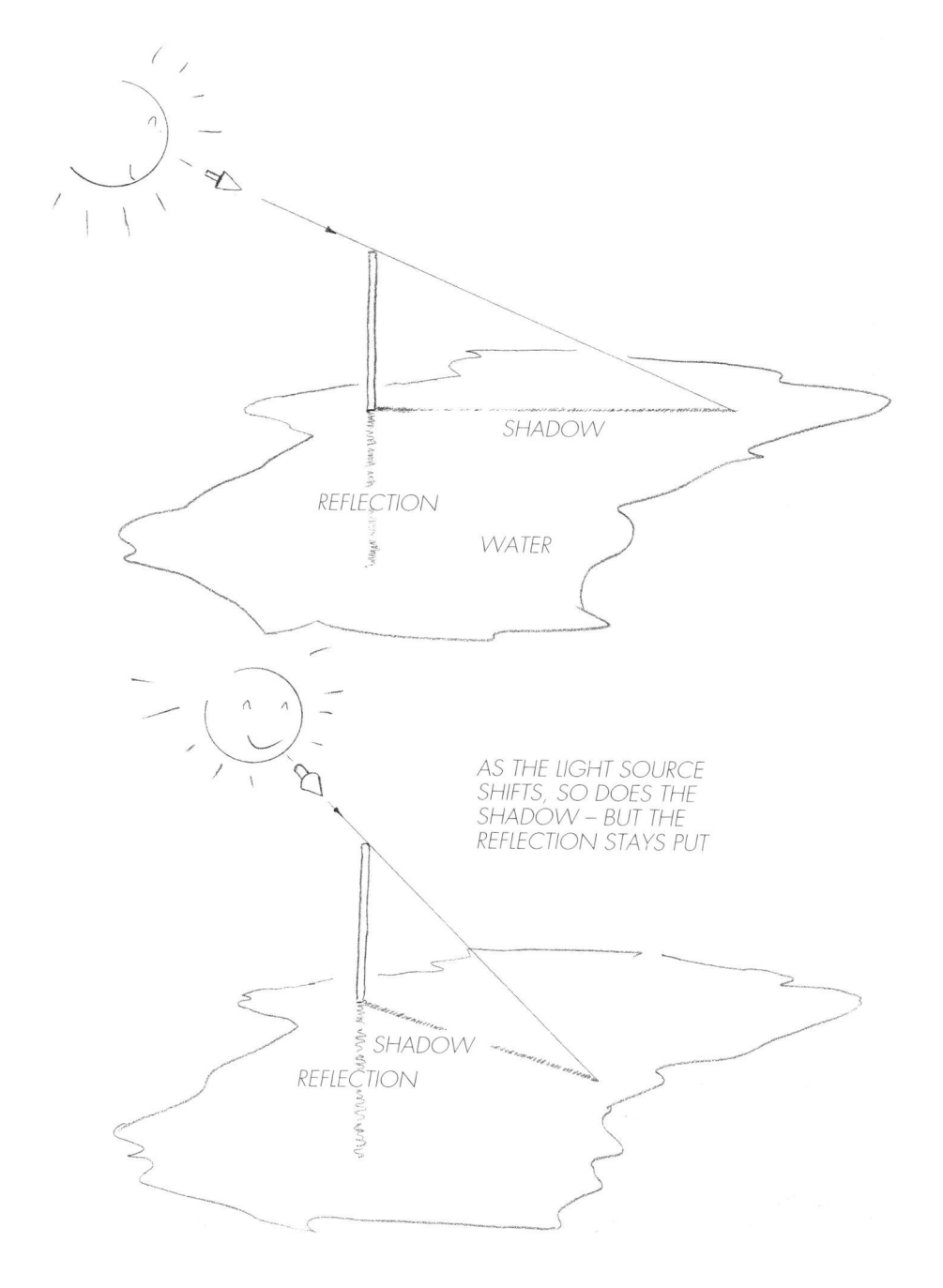

SHADOW

REFLECTION

WATER

AS THE LIGHT SOURCE SHIFTS, SO DOES THE SHADOW – BUT THE REFLECTION STAYS PUT

SHADOW

REFLECTION

Shadows

Multiple vs. Single Shadows

If you have a single light source, you get a single cast shadow; with two light sources you get two shadows **(right center)**.

In fact, theoretically there could be as many shadows as there are light sources. This doesn't quite work out in reality, however, because the area the shadows are cast on eventually becomes so awash with light from all those sources that no shadows at all are discernible. Still, it's not uncommon to have two, three, or four sources. When painting a still life indoors, for example, there could be light from a window (sunlight) and light from a couple of different lamps. It's important to decide in such cases whether you want (a) multiple light sources and the multiple shadows they cause, or (b) a single light source and single shadows. The former is more natural and may give your subject a more ordinary look; the latter offers a more dramatic "spotlighted" look.

One of the effects of multiple light sources is to make shadows less dark, because the light from each source invades the shadow caused by the other source. A second effect is that the edges of the shadows will be less sharp.

Notice in the sketch at **top** that the area where the two shadows overlap is darker than the rest of the shadows. That's because light doesn't get to this area from either source.

While checking up on my own understanding of shadows by playing with the lights at my desk, I rediscovered something I had almost forgotten: a "single" light source can give you a multiple shadow. Here's the arrangement I have in front of me **(bottom)** What I get is two shadows, a darker inner one and a lighter outer one.

What's happening is this: The bulb is one light source and the light rays from it alone would give me a single shadow, but the reflector around the bulb is also sending out light rays. Some of the light from the reflector is coming at the block from a wider angle than the rays from the bulb, and those rays get past the block and fall within the original shadow area, lightening that area wherever they fall.

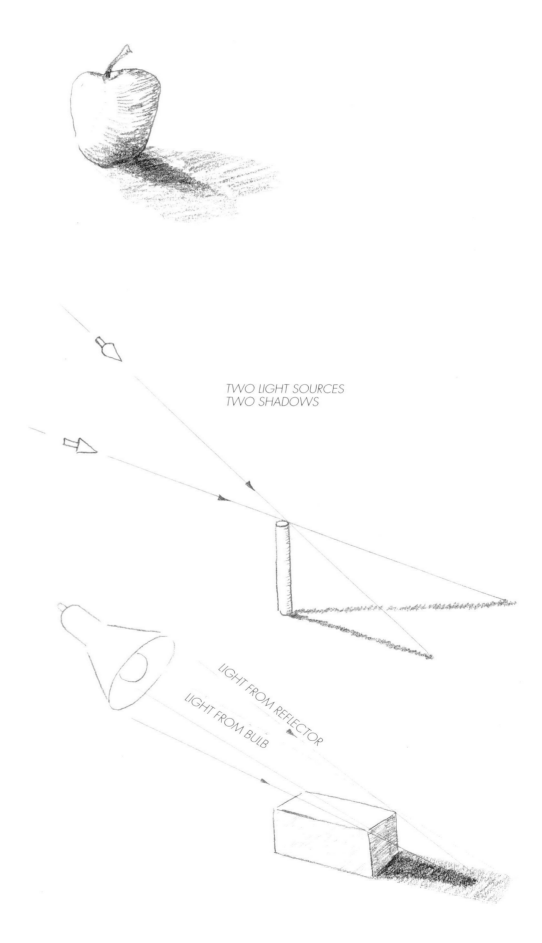

TWO LIGHT SOURCES TWO SHADOWS

LIGHT FROM REFLECTOR

LIGHT FROM BULB

Figuring Them Out

Sometimes it's difficult to figure out how a shadow from a given object would fall over a particular surface. Clearly, the best way to get a shadow right is to photograph the subject when the shadows are where you want them. Then, despite the sun's shifting in the sky or your children's shifting of your lamp, you can refer to the photograph. That's not cheating, just smart.

When all else fails, I have resorted to the dark-room-and-flashlight method. It's patented, but I'll share it with you. Set up something roughly similar to the thing you're trying to understand, darken the room, and use a flashlight as a "sun." (Obviously, if what you're working on is a still life, this is all unnecessary – you simply look at the still life and see how the shadows are behaving.)

As an example, suppose you want to see what sort of shadow a tree trunk will cast on a brick wall with recessed mortar joints. Sounds simple, I know, but just which way *does* the shadow go when it gets into those recessed joints?

Find a few fat books and a few thin ones and pile them up. The fat books are bricks, the skinny ones are mortar joints.

Now turn out the lights (no fooling around!) and hold the flashlight behind a stick or ruler representing the tree trunk, and you'll have an immediate and unequivocal answer to your question **(above right)**. (By the way, the flashlight has the same problem as the lamp I discussed above. Its reflector causes multiple shadows. Hold it as far behind the stick as you can reach to get sharper shadows.)

There's Stuff in There

Look into any shadow and what do you see? Certainly not total blackness, which is the way shadows are often painted. Peer intently into a shadowed area, and you'll find a lot going on there. Perhaps the first thing you'll notice is some rich color. Whatever color is there in the shadowed object may well look more intense than if the shadow were absent, because you're seeing it relative to all that darkness.

The next thing you'll notice is that you can find an extraordinary amount of detail in the shadow – detail that might be lost or washed out in the full glare of sunlight. Another common discovery is that the shadow is by no means uniform in darkness, or value.

The final thing to pay attention to is the nature of the edges of a shadow. Shadows cast in sunlight tend to be sharp, since the sun is a single light source not surrounded by an annoying lamp reflector. Yet the edges you see on shadows outdoors are not always crisp. The edges will be softened if the shadow is falling over some textured area, such as a lawn or hayfield, as opposed to a smooth concrete highway. They may also be softened by strong light bouncing into the shadow from nearby objects, such as bright, white buildings. If you paint shadows too rigidly, too sharply, they'll look pasted-on and unnatural.

Shadows Obey the Law

Most often the cast shadows we draw are rather irregular shapes cast on irregular surfaces by irregular objects, so the best you can do is observe the shadows' shapes and draw them the way you see them. But to help you understand the irregular shapes you see, let's study what happens in an orderly situation such as the one **(bottom left)**. What we have is a neat cube in one-point perspective casting a neat shadow on a flat surface. The thing to notice here is that the edges of such shadows obey the rules of perspective. In this case, for example, the outer edge of the shadow recedes to the same vanishing point as the edges of the cube.

In the next example, **below right**, the shadow cast by the sphere would be circular, if you could view it from directly above. But in keeping with our knowledge of perspective, this circle seen from the side is an ellipse.

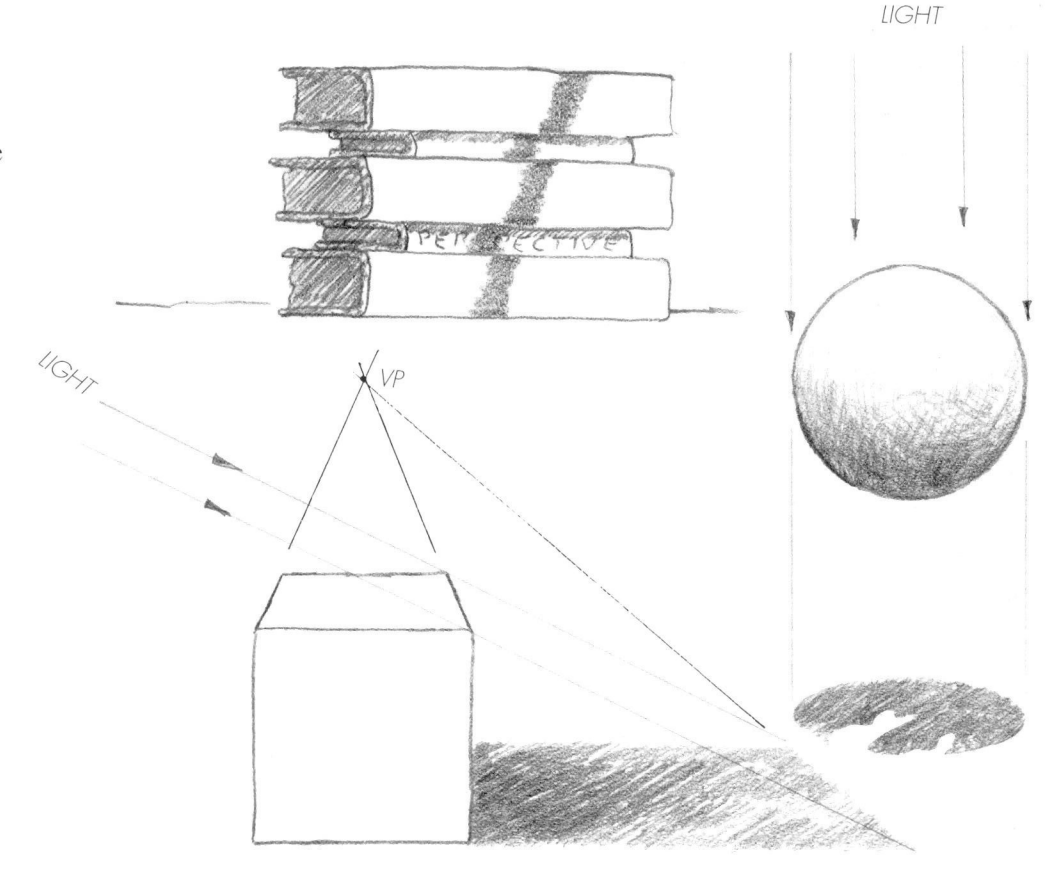

Let's play in the dark. You'll need a flashlight, some books, and a piece of stiff paper or light cardboard. The problem is to simulate in your studio some conditions you're not sure of concerning shadows.

a) Stack three or so fat books and the same number of thinner ones in alternating fashion, letting the thick ones stick out beyond the thin ones. Using your flashlight and a yardstick, cast shadows on this simulated brick wall from the left, from the right, and straight ahead. Make notes to remind you how the shadows look as they jump the intended "mortar joints." Also move the flashlight higher and lower and see what effect this has, especially on the shadows cast by the edges of the "bricks."

b) Repeat a), but this time have protruding "mortar joints." Note what happens to the shadows when they hit a bulging mortar joint.

c) Fold a piece of stiff paper or light cardboard in the shape of board siding. Cast shadows over the siding using the flashlight and yardstick in many positions. Stick a small nail part way into the "siding" and note its shadow. Then use a bent nail and watch how its shadow performs.

d) You can leave the lights on for this one. Lay out a succession of materials of differing values (lightness and darkness) and differing textures – for example, a strip of smooth white paper, a strip of black or gray paper, a piece of terrycloth towel. Use your flashlight or a lamp to cast a shadow simultaneously over all these materials, and notice the differences in apparent darkness of the shadow as it passes over each material and the crispness of the edge of the shadow on smooth versus textured materials. To get a better simulation of sunlight and avoid the "double" shadows the flashlight will give you, cut a one-inch round hole in a piece of cardboard and hold it in front of the flashlight so that only light directly from the bulb gets through.

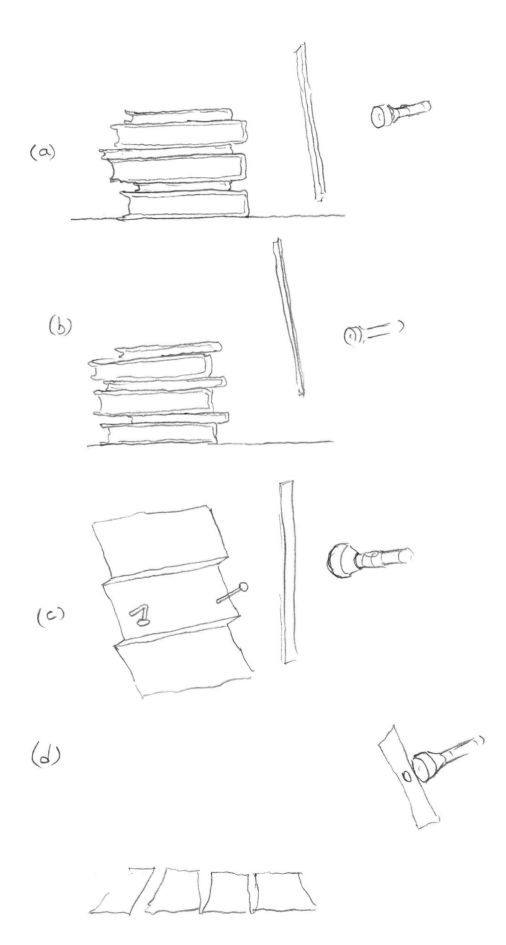

(a)

(b)

(c)

(d)

Reflections

We see an object because light travels from that object to our eyes. We see a *reflection* of an object because light travels from the object to a relatively smooth surface and bounces from that surface toward our eyes.

ANGLE OF INCIDENCE = ANGLE OF REFLECTION

NOPE!

REAR-VIEW MIRROR

NO MATTER HOW THE MIRROR IS TILTED, LIGHT STRIKING IT AT A CERTAIN ANGLE BOUNCES AWAY AT THAT SAME ANGLE

All that's necessary in order to see a reflection of an object is that there be some reflecting surface, such as water, situated at the right distance between you and the object. There must obviously be some source of light in order for anything to be seen, but the *position* of the light source has nothing to do with the reflection's position. Move the sun anywhere you want and the reflection will stay put.

There is a rule in physics that governs reflections, but it's an easy one that even we absent-minded painters can understand and retain. Formally stated, the rule is this:

The angle of incidence equals the angle of reflection.

Or, when light whacks a smooth surface and bounces off, it bounces off at the same angle at which it whacked it, as shown at **top**. Always. It never bounces as in the **center** drawing.

These diagrams show only a single ray of light coming from the tree. Actually, there are rays of light coming from every single tiny bit of the tree and they radiate in all directions. But the rays in which we're interested are only those which strike the water surface at just the right place so that their bounce will take them directly to the viewer's eye. Billions of rays manage to behave and make it to the viewer, and the viewer sees a complete tree stretched across the water.

If you drive a car, you're familiar with another example of how reflections behave. When you glance into your rear-view mirror to watch what's going on behind you, you're taking advantage of the rule we stated above. Light entering your rear window from whatever is behind your car strikes your mirror and bounces off the mirror toward your eyes **(bottom left)**.

That is, it does if your mirror is tilted properly. If it's not, you of course adjust it. What you're doing is steering the light so that it will reach your eyes rather than bounce off somewhere else. If the mirror is twisted too far toward you, then the image from behind you gets lost **(bottom right)**.

Reflections

Deportment

A reflection behaves very well. It's always predictable. If you see a reflection of a vertical object stretching across a pond, it always aims right toward you. A friend off to your left or right will see the same object reflected, but the reflection he sees will aim right toward him. No two people see precisely the same reflection. A reflection, after all, is defined by the light that makes its way to *your* eyes.

If an object is not vertical, some important and still totally predictable things happen to its reflection. Suppose you're looking at a lone piling sticking out of the water. Depending on whether it's vertical or leaning, you'll see one of the reflections shown **below left** and **center**.

How about a piling leaning toward you or away from you? In the previous example, the reflection was the same size as the piling. Here, however, the reflection appears shorter than the piling as the piling tilts away from you and longer when the piling tilts toward you **(below)**.

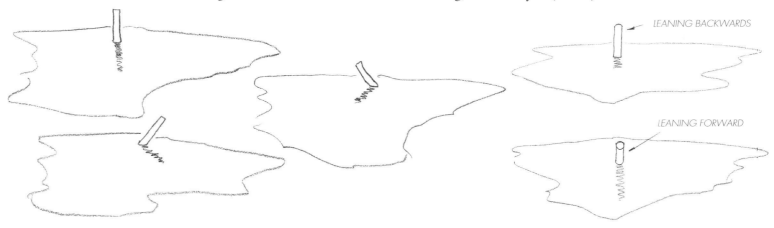

LEANING BACKWARDS

LEANING FORWARD

Exercise 8 / **Reflections**

Lay a flat mirror face up on the table to simulate a pond. It's best to have a mirror at least half a square meter, but a smaller one will work. If you have no flat mirror you can easily make one for our purposes by laying a piece of clean plexiglas or similar rigid glazing over a piece of black matboard.

a) Set up various objects at the edge of your simulated pond and view them from across the pond. Something like a large marker will do well. First stand the marker on end, vertically, and notice that the reflection is about as long as the marker. Tilt the marker to the right and to the left and see which way the reflection goes. Now tilt the marker toward you and watch the relative lengths of the marker and its reflection. Do the same tilting the marker away from you. Try combinations of tilts, such as away and to the right.

b) Set the marker vertically at the far edge of the mirror. Get comfortable in a position where you can see its reflection stretched out across the "pond" toward you. Don't move. Have a friend lay a small object (a tack, perhaps) at the end of the reflection nearest you. Your friend won't be seeing the same reflection as you, so you'll have to guide him or her in placing the tack. When the tack is in place at the end of the reflection *as you see it*, get up and stand over the mirror and prepare for a surprise. That reflection you saw as quite short actually stretched a long way across your "pond"!

c) Set the marker anywhere on the mirror. Lay a piece of white paper alongside it and turn out the room lights. Shine a flashlight on the marker so that the marker casts a shadow on the paper (the paper is only there because it makes the shadow easier to see). Move the flashlight as if it were the sun in the sky and watch how both the direction and length of the shadow change, but notice that the *reflection never changes* as long as you keep your head in the same place. (This may be easier to do with someone else moving the light for you.) Keep moving the flashlight and notice that there is only one position at which the reflection and the shadow happen to coincide – that's when the light is directly behind the marker, so that you and the light source and the marker all line up.

The exercise proves that what I said would happen does happen, but it doesn't explain why. Understanding the "why" involves some geometry which is really not too relevant here. As a painter, all you'll need is to have a good general understanding of how and why things happen and then to rely on observation to resolve particular problems.

It's fairly common in landscape painting for reflections to be the same size as the objects being reflected. In cases where there seems to be a departure from this general rule, you have two tools to rely on for getting things right: (1) Always "measure" what you see before you, using the pencil-and-thumb method, and trust in your measurements; (2) When in doubt (for example, when you're dreaming up a scene rather than painting from an actual situation) set up a reflecting surface, such as a flat mirror, and test out what happens.

Broken Reflections

I just finished telling you that reflections will usually be the same size as the objects being reflected. However, there are important exceptions to this "rule." Have you ever wondered why we see a moon's reflection stretching across miles of water? Or why we see long reflections of automobile taillights in the street on a rainy night? Or why we see tree reflections stretching all the way across a lake on a breezy day?

Vertical objects and their reflections are the same size *if the reflecting surface is relatively smooth* – a mirror, for example, or a shiny desk top, or a calm body of water. The ocean and the rainy road and the lake on a breezy day, however, are never smooth; they are imperfect reflectors. In all three cases we have not just a single, smooth, continuous surface, but a surface made up of zillions of tiny, curved reflectors.

If you could look at a cross section of a piece of pavement, for example, covered by a film of rainwater, it would look something like the drawing at **top right**.

Each of those tiny knobs of pavement covered with a film of water (and oil, probably) is a miniature curved mirror. Light rays from the object, let's say a taillight, strike all those teeny curved mirrors at lots of angles **(center)**.

Some of those light rays are bound to hit a knob at such an angle that they will bounce in the direction of your eye (the angle of incidence equals the angle of reflection), while most will bounce elsewhere and be lost. But the effect is as though there were literally thousands of little mirrors stretching all the way from the taillight to your feet, each one tilted at just the right angle to bounce some light up to your eye.

The same thing happens if you're looking across a water surface that is at all rippled. Each little wavelet is a potential curved mirror, and many of them will succeed in reflecting light in your direction **(bottom)**. You may have noticed on a moonlit night, if you were not being otherwise distracted, that not only does this fuzzy moon reflection come far across the water, but there are occasional flickers of reflections off

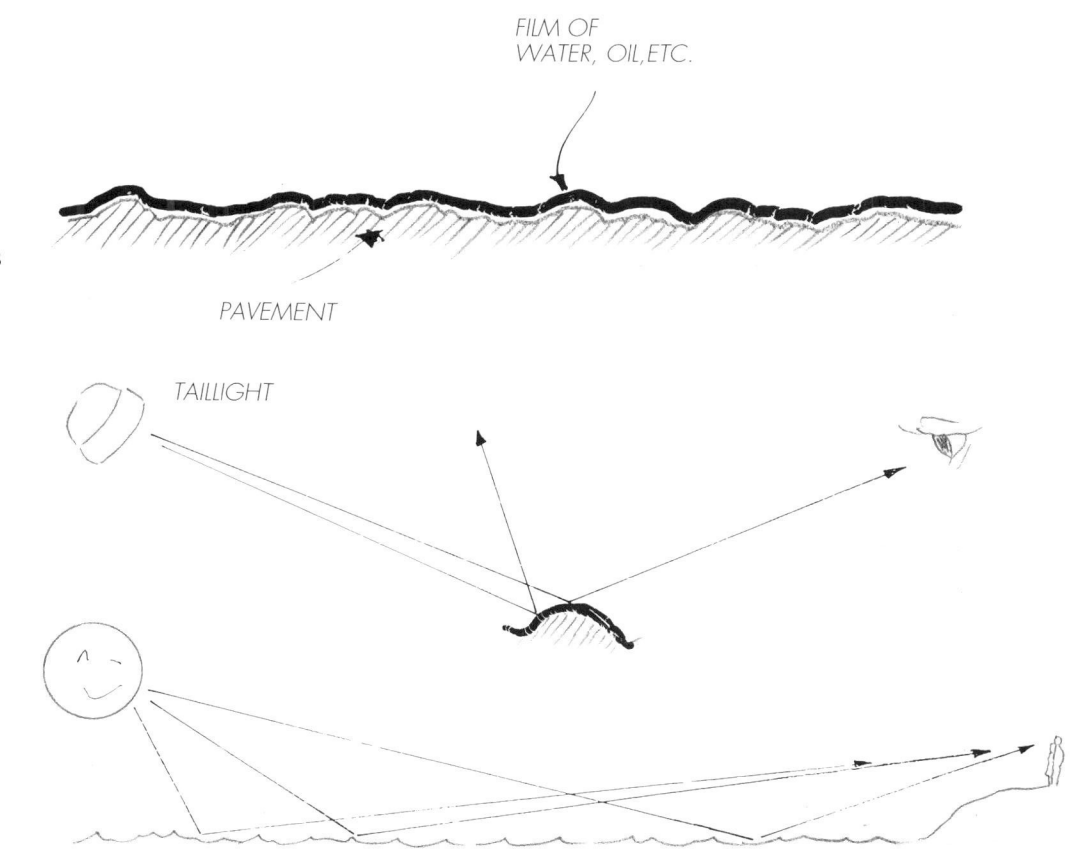

FILM OF WATER, OIL, ETC.

PAVEMENT

TAILLIGHT

to the side of the main beam. This happens whenever a wavelet is in just the right position to direct a moonbeam toward your eyes.

Exercise 9 / **Broken Reflections**

We're going to simulate what happens to reflections on a rainy night. Turn on your flashlight and turn off the room lights. Lay the flashlight at the far edge of your mirror with the lit end facing you. Pretend it's a car's taillight. The mirror is the road surface. So far, if your mirror is reasonably clean, all you see is a crisp reflection of the taillight.

Now squirt some droplets from a spray bottle containing water, gin, or whatever onto the mirror between you and the flashlight. Don't squirt too hard and not directly at the mirror: just let droplets settle onto the mirror, like raindrops falling on a road. The little droplets will act like a rough, water-covered road and will begin to disperse little broken light reflections. You'll notice the crisp reflection of the flashlight will gradually fade and a fuzzy reflection will stretch out toward you. Keep giving short squirts until this happens. This simulation won't be as dramatic as the real thing on a rainy night, but it'll give you a good idea what happens. The flashlight, of course, can represent the moon and the wet mirror, a lake. You could produce similar results with a pan of water. Have someone vibrate the pan enough to disturb the water surface and observe how the flashlight's reflection becomes broken.

Reflections

Effects of Distance

Sooner or later in your landscape painting the question will arise: how far back can this object be and still be seen as a reflection? In the sketch **below**, for instance, does it make a difference whether the hill is close to the edge of the water or far back?

It certainly does. For a given height hill, the farther back you move it, the shorter its reflection becomes. The two versions of this scene shown **center** are entirely plausible.

In (a) I've kept the hill the same height but moved it farther back into the distance. In (b) I've moved it so far back that it no longer reflects.

What happens in (b) is illustrated in the side view **(bottom)**. Light from the hill cannot strike the water at such an angle as to reach the observer's eye.

What this means to you as an artist is that you can feel free to make objects either reflect or not, as you wish, simply by placing them far enough forward or back in the painting. If you decide you don't want the hill in my example to cause a reflection, simply leave it alone, and let it represent a faraway hill. Don't forget, however, to make it feel distant by using the appropriate perspective techniques, such as aerial perspective and blurred edges.

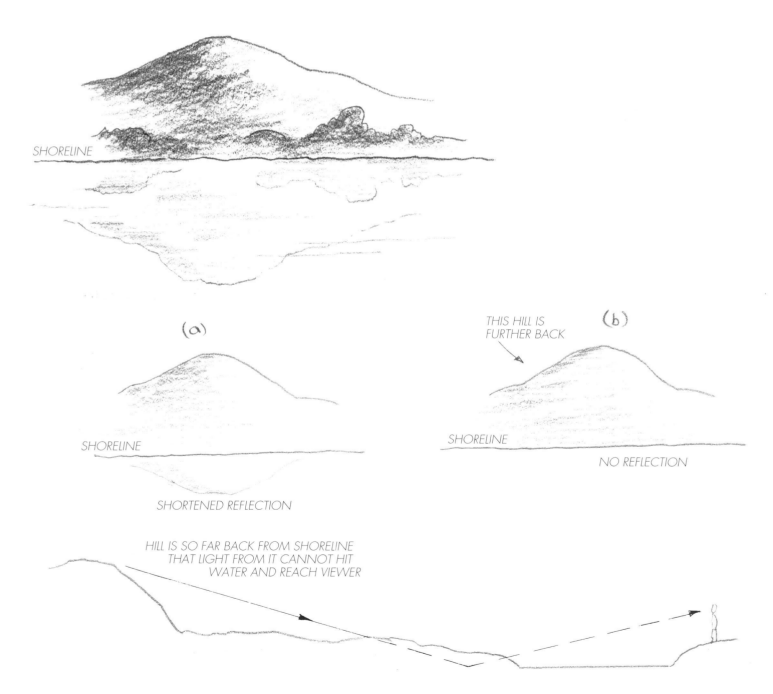

SHORELINE

(a)

SHORELINE

SHORTENED REFLECTION

THIS HILL IS FURTHER BACK

(b)

SHORELINE

NO REFLECTION

HILL IS SO FAR BACK FROM SHORELINE THAT LIGHT FROM IT CANNOT HIT WATER AND REACH VIEWER

Read all instructions for Exercises 10 and 11 before cutting out house on next page. If you want to avoid destroying what appears on this other side of this page, trace the template and transfer it to another piece of paper or cardboard.

You can very often see parts of a structure in its reflection that are not visible in the structure itself. Build a little house from the template supplied. Glue or tape the base together and fasten the roof on. Then place the house at the edge of your mirror and view its reflection as you rotate the house through various positions. You'll see that in some positions the underside of the roof overhang is visible in the reflection even though all you see looking at the house itself is the outer surface of the roof. (Save the house for the next exercise.)

If you don't feel like making the house, simply pile up some books at the edge of the mirror, with the top books overlapping the bottom books in your direction. You'll see in the reflection the bottoms of those overlapping books.

Now we'll build a mountain and use it along with the house. Cut out the mountain and fold back the two ends so that it will stand up. Place your house at the far edge of the mirror. Put the mountain directly behind it, as if it were simply a hill right behind the house. Look at the reflections from across the pond. You'll see the reflection of the hill extending beyond the reflection of the house.

Now move the hill back gradually and watch as its reflection disappears behind the house. Finally, when you move the hill far enough back, it ceases to reflect at all. The importance of what you've seen is this: you can decide whether you want an object to reflect or not simply by moving it closer to or farther from the reflecting surface, without in any way altering its height.

Other Reflections

While a major portion of the reflections you encounter in landscape painting are on flat, horizontal surfaces, there are plenty of reflections in vertical surfaces, such as windows and shiny machinery, and indoors there are reflections in all kinds of glassware, metallic objects, tile, polished wood, and so on. Treatment of such reflections would require a workbook of its own, but I can offer you here a few things to watch for.

First, as always, paint what you see. There are no rules needed for that. But look carefully. You might be painting a rounded silver bowl, for example, and the reflections of objects both inside and outside the bowl, and find that some very strange (but geometrically predictable) things happen in the reflections. Sometimes the reflection is upside-down compared to the object, sometimes it's split into two reflections, and sometimes it's warped and almost shapeless. The size of the object and the size of the reflection may be markedly different. Stick your nose in there and see what those reflections are doing.

Second, simplify complicated reflections so that they don't take over the painting (unless, of course, reflections are really the subject of your painting). You usually don't need to paint a reflection literally – often a few well-placed blobs of color will do.

Third, if you're not sure what would happen under particular circumstances, fall back on tests such as those we performed in the preceding exercises. Simulate a condition you're not sure of.

Exercise 10/**Reflecting Hidden Surfaces**

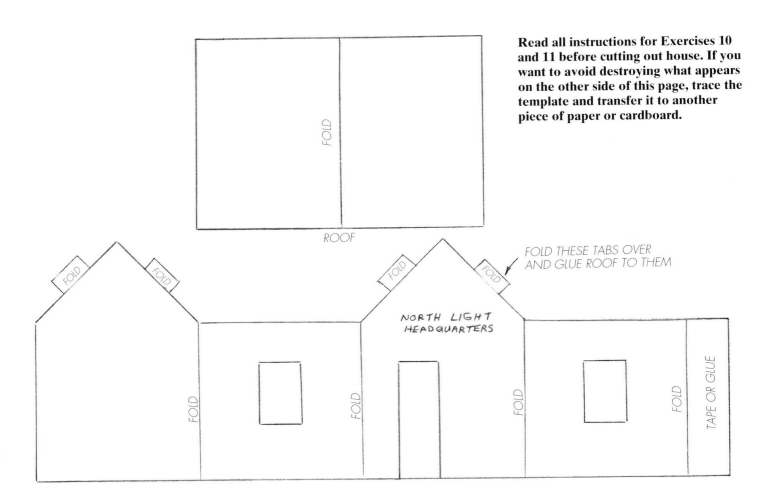

ROOF

Read all instructions for Exercises 10 and 11 before cutting out house. If you want to avoid destroying what appears on the other side of this page, trace the template and transfer it to another piece of paper or cardboard.

FOLD THESE TABS OVER AND GLUE ROOF TO THEM

NORTH LIGHT HEADQUARTERS

FOLD

FOLD

FOLD

FOLD

TAPE OR GLUE

Exercise 11/**Reflections and Distance**

MOUNTAIN

FOLD BACK

FOLD BACK

Refractions

I said in the last section that, for practical purposes, light can be considered to travel in a straight line. It can be "bent," however, when it leaves one medium, such as water, and enters another medium, such as air, at an angle. What happens is something like the diagram at **top right**.

The reason the shaft of light changes direction as it emerges from the water to the air is that it travels more slowly in the denser water than in air. I always picture the beam as doing a sort of little cartwheel as one side of the beam breaks through the surface of the "thick" water and finds freedom in the thin air. As soon as the entire beam is free in the air the light continues in its new straight-line direction.

An observer looking down at the fish in the sketch at **center right** will not see it where it really is, but where the dotted image is. As far as the observer's eye and brain are concerned, the light came from A, not from B. Our seeing apparatus accepts the light that enters the eye and interprets it as having traveled in a straight line.

What refraction means to most people is that you can't always trust what you see. If you shove a straight stick into some water, for example, you'll "see" a bent stick because of refraction. Go ahead, hold a pencil or a stick in a bowl of water and watch it bend.

Or look at an object through a bottle or a glass. The sketch at **bottom right** shows how I see a marker through a decanter half-filled with water.

For a painter, refraction offers some visual delights, especially in painting glass objects. As in the case of my decanter, all kinds of devilish warps occur as light from an object passes through various combinations of air, glass and liquids before reaching your eye. When painting such a subject, don't be afraid to paint what you see.

LIGHT BEAM

AIR

WATER

OBSERVER

AIR

WATER

A

B

GLASS DECANTER

MAGIC MARKER →

THE ODD-SHAPED BLOBS ARE HOW I SEE THE MARKER THROUGH THE VARIOUS COMBINATIONS OF AIR, GLASS AND WATER

WATER LEVEL

Common Goofs

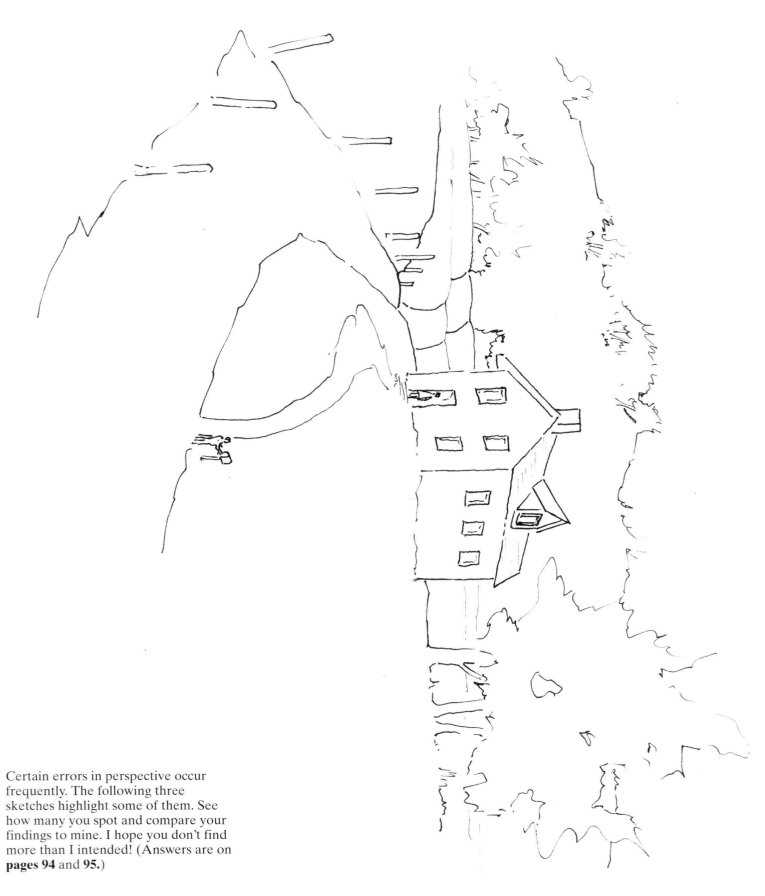

Certain errors in perspective occur frequently. The following three sketches highlight some of them. See how many you spot and compare your findings to mine. I hope you don't find more than I intended! (Answers are on **pages 94** and **95.**)

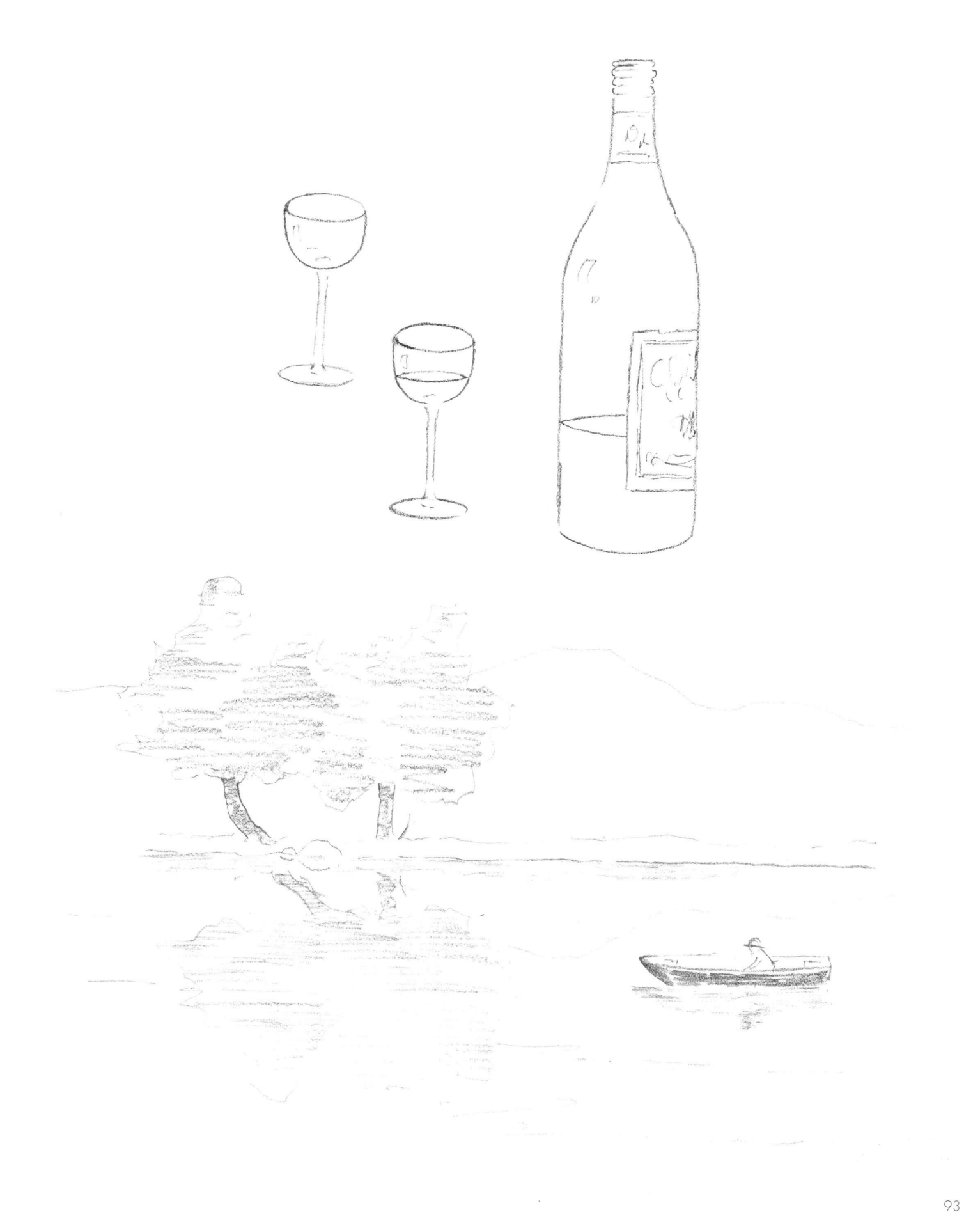

Common Goofs

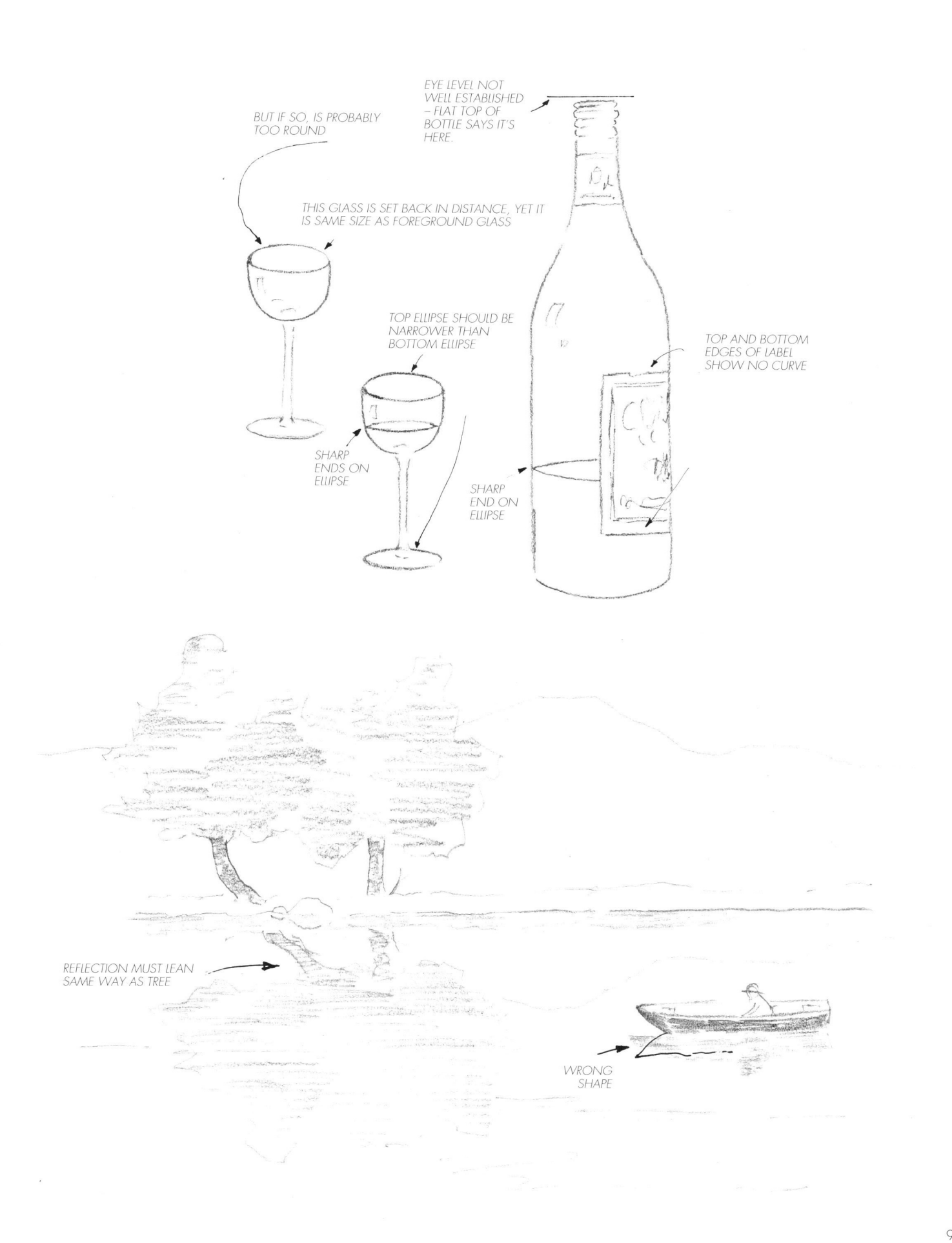

BUT IF SO, IS PROBABLY TOO ROUND

EYE LEVEL NOT WELL ESTABLISHED – FLAT TOP OF BOTTLE SAYS IT'S HERE.

THIS GLASS IS SET BACK IN DISTANCE, YET IT IS SAME SIZE AS FOREGROUND GLASS

TOP ELLIPSE SHOULD BE NARROWER THAN BOTTOM ELLIPSE

TOP AND BOTTOM EDGES OF LABEL SHOW NO CURVE

SHARP ENDS ON ELLIPSE

SHARP END ON ELLIPSE

REFLECTION MUST LEAN SAME WAY AS TREE

WRONG SHAPE

Limitations

Be a little careful in applying the "rules" of perspective. Although the perspective techniques are powerful tools, they have their limitations. What's "right" mathematically or theoretically may not be "right" for your painting.

Earlier, for example, we discussed an accurate way to space objects, such as poles, in such a way that they would recede properly. Although the method discussed will give you an accurate division of spaces, the result might not always be pleasing.

Several scholars have experimented with this very example by presenting people with pictures of receding poles in which perspective (linear perspective, to be more precise) was used rigidly and asking them to choose between those pictures and ones in which certain liberties were taken. In the latter, the receding poles were not made to bunch together quite as rapidly as perspective "rules" would dictate. People chose strongly in favor of the latter.

It's not that linear perspective is wrong – it pretty much duplicates what a good camera would record – it's just that there's no denying certain psychological urges people have for arranging things in certain ways. In the case of the poles, people seemed not to want them to recede quite as precipitously as they really did. I won't pretend to analyze what makes those things happen – I'm only suggesting that you need to know when a tool has done all it can for you and needs to be abandoned in favor of gut feeling.

Another example: linear perspective is only useful within the normal human "cone of vision" – that is, the area you can see ahead, left and right, up and down, without moving your head or eyes. Beyond that space, in peripheral vision, things get pretty distorted. And beyond that space, linear perspective also gets distorted and ineffective.

A good example of a failing of linear perspective is in painting a very long mural, or perhaps an ornamented frieze along the top edge of a building.

It's quite impossible to view such long scenes without actually physically moving and strolling along the length of the picture, or standing so far back that you can see everything at once but can discern little detail. What many artists have resorted to in such situations is to break the picture into a series of scenes, each with its own vanishing points, rather than attempt one long scene with a single set of vanishing points.

Despite such limitations, perspective works well for the vast majority of the scenes most of us draw and paint.

Now that you've waded through both workbooks and assimilated everything, let me plead one final time for moderation in the application of what we've covered. Perspective is a tool for helping to gain a sense of depth in a drawing or painting, nothing more. Perspective is not an end in itself. Too rigidly applied, the techniques of perspective could smother an otherwise expressive painting. Don't let them tie you down.